A TURBULENT LENS

THE PHOTOGRAPHIC ART OF
VIRNA HAFFER

MARGARET E. BULLOCK

CHRISTINA S. HENDERSON

DAVID F. MARTIN

TACOMA ART MUSEUM
TACOMA, WASHINGTON

2009003532

Published in conjunction with the exhibition *A Turbulent Lens: The Photographic Art of Virna Haffer* which appears at Tacoma Art Museum from July 2 through October 16, 2011. It takes part in the *Northwest Perspective Series* of one-person exhibitions devoted to artists of the region.

The publication is made possible by the generous support of the Randall Family, The Jean E. Thomson Foundation, and those individuals listed on page 8.

Tacoma Art Museum
1701 Pacific Avenue
Tacoma, Washington 98402

Distributed by
University of Washington Press
P.O. Box 50096
Seattle, WA 98145-5096
www.washington.edu/uwpress

PUBLISHER'S CATALOGING-IN-PUBLICATION DATA

Haffer, Virna.
 A turbulent lens : the photographic art of Virna Haffer / Margaret E. Bullock, Christina S. Henderson, [and] David F. Martin.

 p. : ill. (some col.) ; cm. -- (Northwest perspective series)

 "Published in conjunction with the exhibition A Turbulent Lens: The Photographic Art of Virna Haffer which appears at Tacoma Art Museum from July 2 through October 16, 2011."--T.p. verso.
 Includes bibliographical references.
 ISBN: 978-0-924335-32-7

 1. Haffer, Virna--Exhibitions. 2. Photography, Artistic--Exhibitions. 3. Women photographers--Northwest, Pacific--20th century--Exhibitions. I. Bullock, Margaret E. II. Henderson, Christina S. III. Martin, David F. (David Francis), 1953- IV. Tacoma Art Museum. V. Title. VI. Series: Northwest perspective series.

TR647.H24 H24 2011
779/.092

Cover: VIRNA HAFFER, *Self Portrait*, 1929. Gelatin silver print with added pigmentation, 11 ½ x 9 ¼ inches. Private Collection.

Frontispiece: VIRNA HAFFER, Untitled, 1944. Gelatin silver print, 9 ⅝ x 7 ⅝ inches. The Randall Family Collection.

Page 144: VIRNA HAFFER, Interior of Virna Haffer's home studio, circa 1940. Scanned from the original negative. Collection of the Washington State Historical Society, gift of the estate of Virna Haffer, 1974.35.10.1620.1.

Back cover: VIRNA HAFFER, Virna Haffer photographing her husband Norman. Scanned from the original negative. Collection of the Washington State Historical Society, gift of the estate of Virna Haffer, 1974.35.10.1871.3.

Designed by Phil Kovacevich
Edited by Rebecca Jaynes
Proofread by Zoe Donnell
Printed and bound in Canada by Friesen's, Inc.

A TURBULENT LENS

THE PHOTOGRAPHIC ART OF
VIRNA HAFFER

NORTHWEST PERSPECTIVE SERIES

TACOMA ART MUSEUM

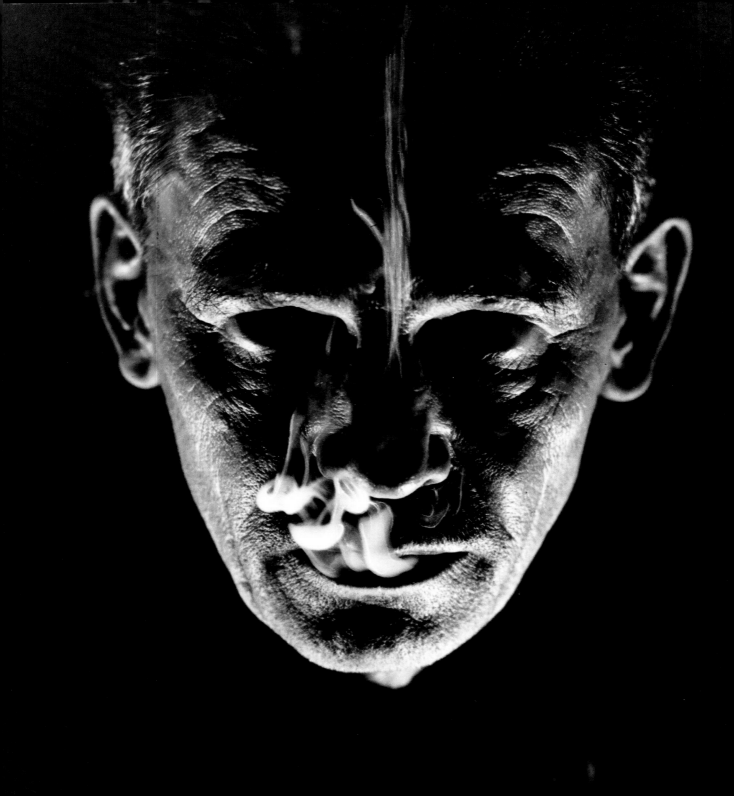

CONTENTS

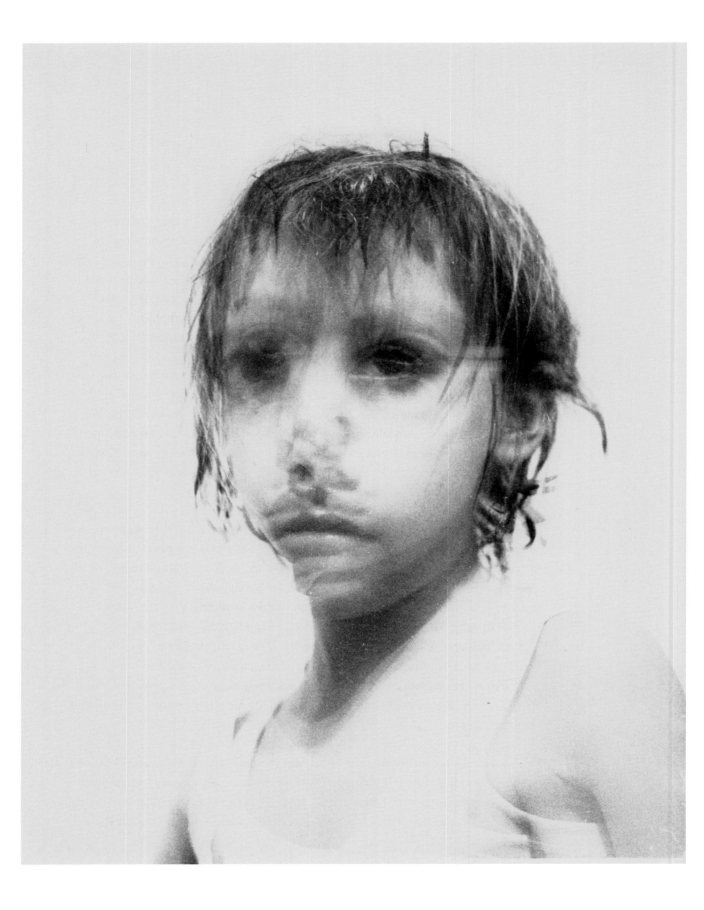

DIRECTOR'S FOREWORD AND ACKNOWLEDGEMENTS

STEPHANIE A. STEBICH

VIRNA HAFFER has been an all too well kept Tacoma secret. Though her commercial work as a studio portraitist, particularly of children, can be found throughout the community, she also was an internationally known and respected photographer in the first half of the twentieth century who has slipped from both regional and national art history books. Her work has lain quietly in archives for decades awaiting reconsideration. This catalogue is a major step toward re-establishing this multi-talented and innovative photographer among the ranks of the Northwest's prominent artists.

Since its founding in 1935, Tacoma Art Museum has focused on the art and artists of the Northwest. In this 75th anniversary year the museum has been celebrating its Tacoma roots by drawing exhibitions from its historical collections of impressionist painting, Japanese woodblock prints, and American works on paper; making Tacoma itself the subject of an exhibition in *Mighty Tacoma: Photographic Portrait 2010*; and featuring the work of distinguished Tacoma native son in *Dale Chihuly's Northwest*.

Given her Tacoma roots, pivotal role in Tacoma's art community throughout her career, and diverse and stunning body of work, Virna Haffer is a perfect subject for Tacoma Art Museum's *Northwest Perspective Series*, which celebrates the work of regional artists through an exhibition and accompanying catalogue. Since the series began in 2003, we have presented major exhibitions featuring Victoria Adams, Michael Brophy, Mary Randlett, Akio Takamori, and Nancy Worden, among others. Originated as the *Twelfth Street Series* in 1993, the project has grown to include a scholarly publication and the purchase of work from the exhibition for the museum's permanent collection. This publication marks the expansion of the *Northwest Perspective Series* to periodically include scholarly projects on historical Northwest artists.

This project has been a cooperative effort of three dedicated scholars: David Martin, who first suggested the exhibition and whose unbounded enthusiasm and support has been instrumental in bringing it to fruition; Christina Henderson, who wrote her insightful master's thesis *Virna Haffer: Regional Artist and Photographer* at Reed

VIRNA HAFFER, Untitled (Jacky Randall), circa 1955. Gelatin silver print, 13 ½ x 10 ¾ inches. Collection of the Washington State Historical Society, gift of the estate of Virna Haffer, 1974.35.12.13.

College which offered the first in-depth biographical study of Haffer and her background; and the museum's Curator of Collections and Special Exhibitions, Margaret Bullock, who has diligently and delightedly guided development of the exhibition and catalogue drawn from an impressive body of some 30,000 of Haffer's prints and negatives.

We are deeply appreciative of the support and enthusiasm of our dedicated trustees and their unwavering commitment to the art of the Northwest. We are also grateful for the collegial support and encouragement of the Washington State Historical Society where the majority of Haffer's work is now located. Finally we are indebted to the generosity of the lenders to the exhibition, and the sponsors of the catalogue who are listed below.

Sharon Archer and Donald Ecklund
Jeffrey and Brenda Atkin
Neil Collins
Jack Curtright, Curtright and Son Tribal Art
Lindsey and Carolyn Echelbarger
Catherine Gill, Art Partners International
John Graham and Beverly Criley Graham
Phillip Henderson
William and Lisa Holderman
John and Annick Impert
Richard Johnson
Wiley and Marianne Kitchell
Kurt Lang and Gladys Engel Lang
Barbara Pitts, Art Partners International
Gene and Lillian Randall
Jacky Randall and Knut Ringen
Norman and Susan Randall
Dennis Reed
Nancy L. Rothwell
Thomas and Dorothy Sheehan
John and Martina Simms
Milton and Sherry Smrstik
The Jean E. Thomson Foundation
Dominic A. Zambito

CURATORS' ACKNOWLEDGEMENTS

THE CATALOGUE'S AUTHORS would like to thank the many individuals whose knowledge, support, and time have made this project possible.

First and foremost, we thank Gene and Lillian Randall, son and daughter-in-law of Virna Haffer. For many years, they have been very patient with numerous interviews and openly shared personal aspects of Virna Haffer's life and art. We would especially like to acknowledge the generous assistance of Jacky Randall, Haffer's granddaughter, and her husband Knut Ringen. Other family members who assisted with this project include Norman and Susan Randall; Dr. Tamara Simon; and Jean-Paul Simon and Jesse Randall.

Secondly, we extend our sincere thanks to our generous colleagues at the Washington State Historical Society, who were unfailingly patient and helpful with months of visits, questions, and requests and without whom we could not have created this exhibition and catalogue. They include Fred Poynter IV, Registrar and Digital Assets Manager; Joy Werlink, Manuscript Specialist; Edward Nolan, Head of Special Collections; Lynette Miller, Head of Collections; Maria Pascualy, Curator; and David Nicandri, Director.

Additional colleagues at archives and museums who were instrumental to this project include Robert Schuler, Photo Archivist, Tacoma Public Library; Hollis Near, Director of Library Services and Bridget Nowlin, Curator of Visual Resources, Cornish College of the Arts; Jodee Fenton, Manager, Special Collections, The Seattle Public Library; Rose Krause, Johnston-Fix Curator of Special Collections, Northwest Museum of Arts & Culture/Eastern Washington State Historical Society; Paul Cabarga, Exhibitions Manager, Henry Art Gallery, University of Washington; Nicolette Bromberg, Visual Materials Curator, University of Washington Libraries, Special Collections; and Nicole Gleadle, Pacific Lutheran University.

Others who contributed their knowledge and insight to this project include Mrs. Wayne B. Knight; Larry Kreisman; Glenn Mason; Judy McGrady, President of the Spokane chapter, Soroptimist International; Rich Miller; Jeffrey Ochsner; Dennis Reed; Linda Rosan, New Tacoma Cemeteries & Funeral Home; and Kenneth and Debbie Zajac.

We want to extend special thanks to Tod Gangler for his extraordinary generosity and his expert printing of several of Virna Haffer's unpublished negatives for the exhibition; to Phil Kovacevich for a beautiful catalogue on an impossible schedule; and to Rebecca Jaynes for her invaluable assistance as editor.

Thank you to Tacoma Art Museum Director Stephanie Stebich and Rock Hushka, Director of Curatorial Administration and Curator of Contemporary and Northwest Art, for their encouragement and support. Among the museum staff we particularly wanted to acknowledge are Zoe Donnell, Curatorial Coordinator, for handling the myriad details of both catalogue and exhibition, and Kara Hefley, Director of Development, for fundraising support. We also want to thank Jessica Wilks, Registrar, Cyrus Smith, Museum Preparator, and Ellen Ito, Exhibition and Collection Assistant, for their work on the design and installation of the exhibition.

To the many catalogue donors and the lenders to the exhibition, thank you for your trust and generosity.

And to our family members who encouraged and supported us through the long research days, late-night writing spells, and deadline stress, our heartfelt thanks go to Dominic Zambito, Whitney Henderson, Megan Henderson, Phillip Henderson, and Becky Bullock.

Virna, we hope we did you proud.

MARGARET E. BULLOCK

CHRISTINA S. HENDERSON

DAVID F. MARTIN

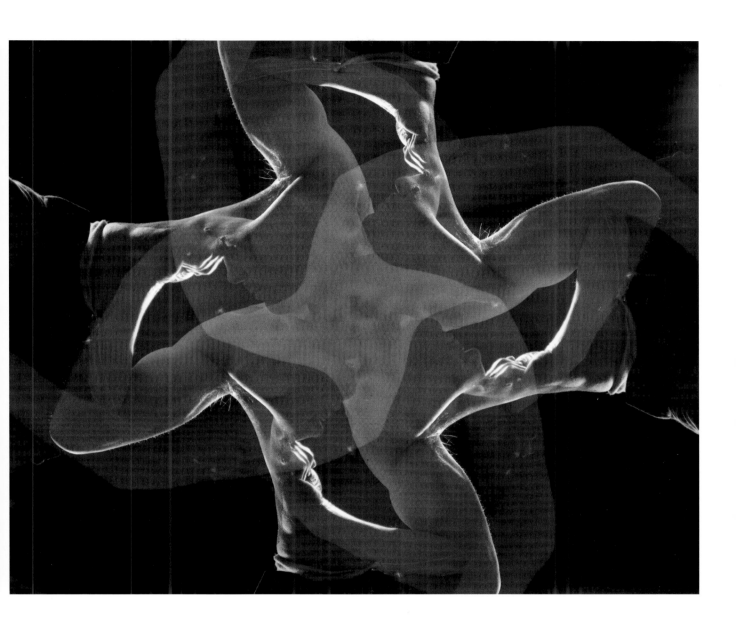

VIRNA HAFFER,
Untitled, circa 1934.
Scanned from the original
negative. Collection of
the Washington State
Historical Society, gift of
the estate of Virna Haffer,
1974.35.10.1871.6.

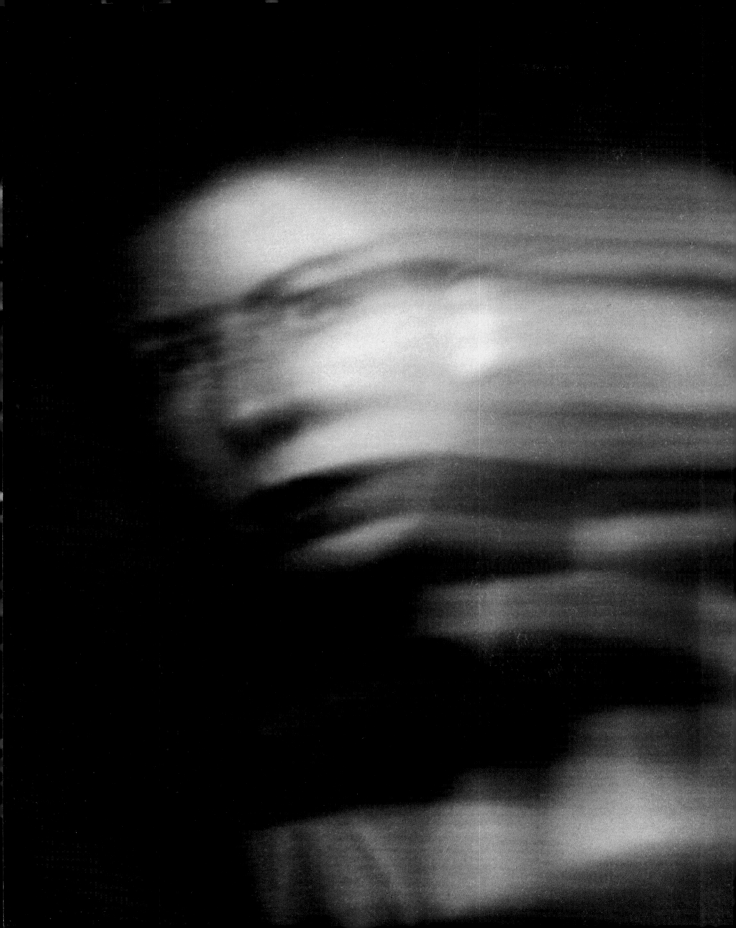

A TURBULENT LENS

Margaret E. Bullock

VIRNA HAFFER LOVED PHOTOGRAPHY in all its aspects from the time she first saw a camera around the age of ten until the end of her six-decade career. Paralleling the development of photography in the early half of the twentieth century, Haffer's history was a perpetual process of discovery and experimentation with a medium that proved to be infinitely more than just a mechanical process. She was an active member of the burgeoning international photography community, and in her body of work can be found images that reflect most of the major movements from the formative years of American photography.

Haffer had an endlessly seeking artistic curiosity. Though this essay considers only her photographic work, she was also a talented musician and writer, and her body of woodblock prints created during the 1930s are worthy of a separate study. However, she devoted most of her creative energy to photography, which in its flexibility seemed to best satisfy her multifaceted creative impulses.

Though Haffer (1899–1974) essayed a variety of photographic styles and techniques, she did not pick them up and drop them lightly but methodically mastered them. Her body of work includes images that can be classified as pictorialist, surrealist, documentary, straight, and modernist, but there is no single label that characterizes her work. That she did not discuss or extensively write about her work and influences further complicates attempts to define her images. From snippets in her published writings, reminiscences from her family and artist friends, and the photographs themselves, it is clear that, like most early twentieth-century American photographers, she was strongly influenced by the ideas of prominent figures, which were absorbed from publications such as *Camera Work* and the *American Annual of Photography* as well as traveling photography exhibitions. But of more immediate importance were her friendships and creative exchanges with Puget Sound photographers, such as her long-time colleague and friend Yukio Morinaga (1888–1968), who printed many of her images, Wayne Albee (1882–1937), and Ella McBride (1862–1965), as well as the collegial relationships she forged with members of the Seattle Camera Club, such as Dr. Kyo Koike (1878–1947) and Frank Asakichi Kunishige (1878–1960), all of which are detailed in David Martin's essay in this

VIRNA HAFFER, Untitled (Self Portrait), circa 1935. Gelatin silver print, 13 ¼ x 11 inches. Collection of the Washington State Historical Society, gift of the estate of Virna Haffer, 1974.35.12.59.

FIGURE 1.1.
VIRNA HAFFER,
Wright Park, 1918.
Gelatin silver print,
5 ⅛ x 3 inches. Collection
of the Washington State
Historical Society, gift of
the estate of Virna Haffer,
1974.35.11.8.36.1.

volume. As well, her regular participation in the international circuit of photography salons kept her abreast of current ideas and techniques.

This essay will discuss Haffer's images and career in relationship to the varied currents in American photography from the late nineteenth century through the 1960s. It does not address the details of her technical processes in depth. Her archives at the Washington State Historical Society and Tacoma Public Library provide a wealth of information on how she arranged, lit, photographed, developed, and printed her works.

Haffer's fascination with photography began around the age of ten when an itinerant photographer came to Home Colony, Washington, on South Puget Sound, where her family had relocated in 1907. She was immediately captivated by both the equipment and resulting images; family scrapbooks show that she quickly became an enthusiastic snapshot photographer. Raised to be independent-minded and self-sufficient, Haffer decided to leave school at the age of fifteen and become a professional photographer. She apprenticed herself to a Tacoma portrait studio where she absorbed the necessary technical skills along with the business aspects of running a commercial studio.

Haffer first began exhibiting her fine art photographs in 1924. (fig. 1.1) These images were clearly influenced by pictorialism, a late nineteenth-century movement born in Europe and quickly adopted in America that was committed to exploring and promoting the artistic potential of photography. From its invention in the 1830s, photography had been primarily considered a mechanical process for straightforward documentation of a particular person or scene. Though many saw the commercial and personal possibilities of the medium, the artistic uses were not broadly acknowledged until the 1890s.

The pictorialists used several different approaches to create their images. Some chose popular painting subjects—still lifes, portraits, and figural tableaux with historical, mythological, or religious content—and photographed them in soft focus or hazy

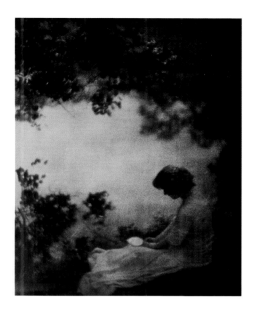

lighting to evoke scenes from memory or dreams. (fig. 1.2) Artists who preferred outdoor scenes waited for particular weather conditions such as fog or snow and the muted light of dawn, twilight, moonrise, and starlight. Others created their effects by manipulating the image in the darkroom. Many used gum bichromate, a resinous coating containing photographic developing chemicals that could be brushed on in layers, much like painting. Images also could be toned silver or gold to lend them an otherworldly atmosphere. The pictorialists argued that using these methods raised photographs from the mechanical to the realm of handmade works of art requiring an artistic eye and touch. (fig. 1.3)

The pictorialist movement caught fire immediately among both hobbyists and dedicated photographers, and an extensive network of camera clubs sprang up worldwide for exhibiting and promoting such works. Many of the clubs sponsored annual exhibitions (called salons), and photographers from all over the world were encouraged to submit works for consideration. Serious proponents of art photography soon became annoyed at the flood of pictorialist images of dubious quality and minimal technical skill and worried that photography's populist appeal would encourage the art world to continue to see it as only a tool for hobbyists rather than a serious artistic medium. In reaction, new groups dedicated to a more meticulous aesthetic approach began to split off from the camera clubs.

In New York, the great dean of American pictorialist photography, Alfred Stieglitz (1864–1946), had formed the Camera Club of New York in 1896, but by 1902 he and some of the other members split off and created a group known as the Photo Secession in an attempt to separate serious practitioners from the hobbyists. Stieglitz, who was artist, gallery owner, author,

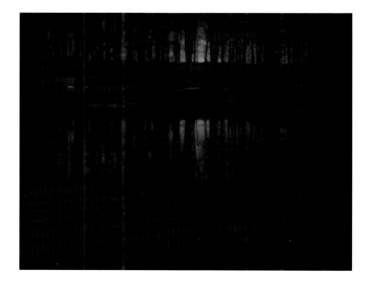

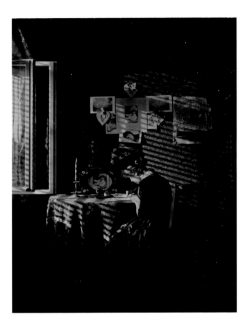

and impresario all in one, strongly believed in photography as a new artistic medium and encouraged free experimentation. (fig. 1.4) Through his 291 Gallery in New York and a publication he started in 1903 called *Camera Work,* he promoted the careers of photographers that he felt were motivated purely by aesthetics. Stieglitz also was a tireless advocate for introducing photography into museum exhibitions and collections, and it was as a result of such projects as the exhibition of over six hundred international pictorialist photographs at the Albright Art Gallery, Buffalo (now the Albright-Knox Art Gallery), in 1910 that the art world began to take notice.

Though *Camera Work* was not published after 1917, past issues were readily available through most camera clubs and many libraries, and the publication remained highly influential on young photographers like Virna Haffer.

Though the focus of Stieglitz and his gallery shifted in the mid 1910s, influenced by new ideas from Europe, pictorialism continued to dominate both American and international photography salons and was the primary style of the members of the Seattle Camera Club as described elsewhere in this catalogue. (fig. 1. 5; see also pages 92, 99, and 100) Like them, Haffer's images from the 1920s are strongly pictorialist. Her *Eleventh Street Bridge* (fig. 1.6) is a typical example. Haffer uses the thick fog as a soft, mysterious setting for her image. The shadowy figure and fragments of the bridge structure that emerge from the haze are stripped of detail and context and are reduced to dark shapes against a luminous gray background.

Haffer employed an array of techniques to create her pictorialist pictures. Predominant is the use of strongly contrasting light and shadow (particularly deep, rich blacks and subtle highlights) as well as smoke and flame (fig. 1.7), which allowed her to create images that suggest an underlying narrative or evoke the feel of a stage set or movie still. A number of elements in Haffer's work also can be

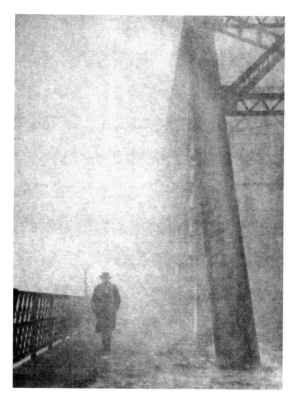

traced to Japanese art and specifically Japanese woodblock prints. This is due in part to her relationships with the many Japanese American members of the Seattle Camera Club as well as the widespread influence of Asian aesthetics in the early twentieth century, particularly on Northwest art. These include the use of patterned backgrounds and texts as decorative elements, close cropping and unusual viewpoints, and flattened depth-of-space. (fig. 1.8; see also fig. 3.38, page 110) As well, Haffer used a technique called bromoil printing in which a photograph is printed and bleached and then colored inks are applied, giving it a painterly or print-like surface. (figs. 1.8 and 1.9; see also fig. 3.32, page 107) Other techniques, such as hand-coloring, photographing through screens, and combining drawing with photography, also appear in her work. Haffer's pictorialist works were readily accepted and promoted by a variety of photographic salons and publications, rapidly earning her an international reputation.

FIGURE 1.6.
VIRNA HAFFER, *Eleventh Street Bridge*, circa 1928. Paper negative print, 9 ½ x 6 ⅝ inches. Collection of the Tacoma Public Library.

FIGURE 1.7.
VIRNA HAFFER, *Mina Quevli*, circa 1930. Gelatin silver print, 11 ½ x 11 inches. Collection of the Washington State Historical Society, gift of the estate of Virna Haffer, 1974.35.11.24.

Mina Quevli (later Mrs. Brewster Morgan) was the oldest daughter of one of Tacoma's pioneer families, who went on to become a successful painter, sculptress, actress, dancer, and writer. She was the model for a number of Haffer's works in the 1930s.

In the late 1920s, Haffer's restless curiosity and unbounded creativity led her to begin incorporating new types of imagery. Clearly she was aware of and intrigued

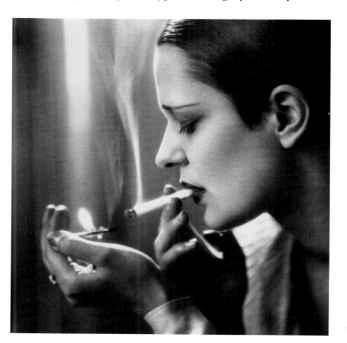

by the photographic experiments of the surrealists, most notably László Moholy-Nagy (1894–1946) and Man Ray (1890–1976). The surrealists were interested in the subjective uses of photography, that is, how it could be used to alter ideas of reality or evoke the power of the mind, particularly the subconscious, memory, and dreams. Moholy-Nagy experimented broadly

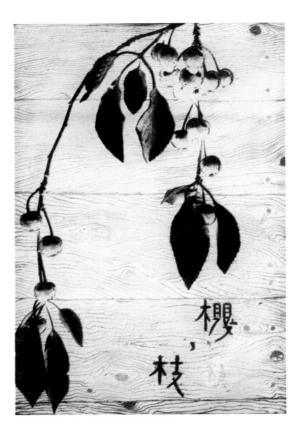

FIGURE 1.8.
VIRNA HAFFER,
Cherry Branch, 1929. Bromoil
print, 9 ½ x 6 ½ inches.
Collection of the Washington
State Historical Society, gift
of the estate of Virna Haffer,
1974.35.68.1.

FIGURE 1.9.
VIRNA HAFFER,
Foundry, circa 1938. Gelatin
silver print with added
pigmentation, 9 ½ x 11 ¾
inches. Collection of the
Washington State Historical
Society, gift of the estate of
Virna Haffer, 1974.35.12.21.

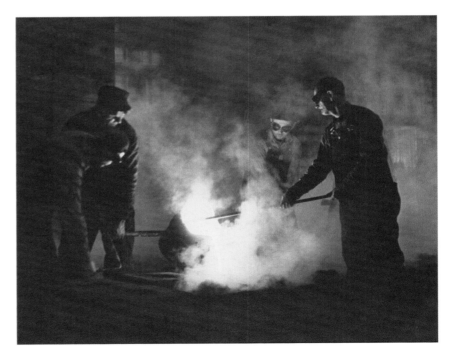

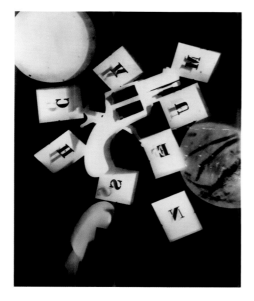

with photography, using composite images, multiple overlapping exposures, eccentric viewpoints, and a non-mechanical photographic process called the photogram—a process Haffer later adopted. To create his photograms, Moholy-Nagy placed objects on paper coated with photographic chemicals then exposed the combination to light; where the objects blocked the light, enigmatic patterns and shapes were left on the paper. Man Ray experimented with photographing incongruous juxtapositions of ordinary objects or combining multiple images to create visual puns or metaphors. Like Moholy-Nagy, he worked with photograms (though he preferred to call them Rayographs). (fig. 1.10) Also popular among the surrealists was photomontage, a mix of photography and other media that was often used to convey political or social messages. Haffer also experimented with layered negatives, abstracted or incongruous combinations of objects, and distorted imagery. (figs. 1.11 and 1.12)

William Mortensen (1897–1965), an experimental photographer who drew on pop culture, movies, and Freudian psychology, also may have influenced Haffer's work.

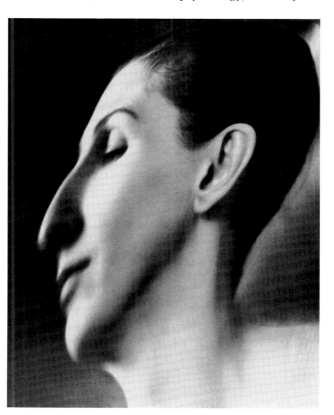

FIGURE 1.10.
MAN RAY (American, 1890-1976), *Rayograph* from *Man Ray: 12 Rayographs. 1921-1928*, Schubert & Kapitzki, Stuttgart, circa 1925, printed circa 1963. Gelatin silver print, 11 ⅜ x 9 ¹⁵⁄₁₆ inches. George Eastman House, International Museum of Photography and Film, 1979:0095:0002.

FIGURE 1.11.
VIRNA HAFFER, *Caricature* (also titled *Study—Kay Harshberger*), circa 1930. Gelatin silver print, 9 ¾ x 7 ⅝ inches. Collection of the Washington State Historical Society, gift of the estate of Virna Haffer, 1974.35.12.32.

Haffer created this distorted image in the darkroom by rotating her horizontal printing frame slightly on its vertical axis, producing a lateral elongation of the photograph.

Mortensen created darkly fantastical tableaux, many with erotic or sinister overtones. (see fig. 3.47, page 114) Haffer often had her sitters dress up and act out characters (fig. 1.13, see also fig. 3.11; page 93), but the body of work that takes this style the furthest is her portfolio of twelve images for an unpublished collaboration with poet Bettie Sale titled *Abundant Wild Oats*. (see pages 126–141) A number of the photographs in this group are reminiscent of Mortensen's in their dramatic staging and eroticism. (fig. 1.14; see also

page 129) Others are further examples of Haffer's work with surrealist photographic methods. (fig. 1.15) What is most unusual about these more experimental works is that Haffer was creating them at the same time that she was producing her soft-focus, sometimes romantic or sentimental, pictorialist works. (see figs. 3.6 and 3.7, pages 90 and 91) Haffer submitted images in both styles to photography salons, sometimes to the same exhibition, and both were equally accepted and acclaimed, reflecting both Haffer's talent for mastering a variety of styles as well as the fluidity of artistic categories that is a hallmark of twentieth-century art.

During the late 1910s, straight photography, a new aesthetic fostered by Alfred Stieglitz and exemplified by the photographer Paul Strand (1890–1976), began to challenge pictorialist manipulation. Proponents were motivated by modernist ideas that embraced urban and industrial subjects as well as images from contemporary life. This new aesthetic avoided manipulation of the print and both confronted and played with the two-dimensionality of the picture plane. The photographer's role

FIGURE 1.12.
VIRNA HAFFER, Untitled, circa 1934. Scanned from the original negative. Collection of the Washington State Historical Society, gift of the estate of Virna Haffer, 1974.35.10.1871.4.

Haffer took several images of her husband's arm and elbow then overlapped and repeated it to create this insect-like shape.

FIGURE 1.13.
VIRNA HAFFER, Untitled (Isabel Keith Morrison), circa 1930. Bromoil print, 8 ⅜ x 8 inches. Collection of the Washington State Historical Society, gift of the estate of Virna Haffer, 1974.35.11.20.

Isabel Keith Morrison was a dancer and dance instructor active in Tacoma in the 1920s. By the following decade, she had moved to Los Angeles where she continued to dance in regional productions and teach.

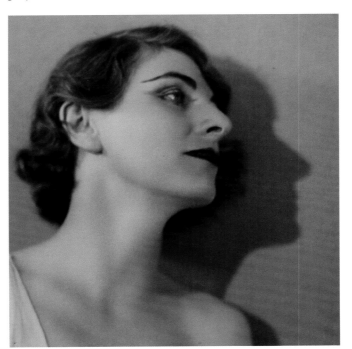

was to recognize and compose the image as well as make final decisions in the darkroom about cropping, emphasis, and toning to create a unique and artistic photograph. Though the images diverged dramatically from the evocative and atmospheric images of the pictorialists, many straight photographers also felt their images carried symbolic meaning or expressed ideas and emotions.

FIGURE 1.14.
VIRNA HAFFER,
Into Cool Music, circa 1934.
Gelatin silver print, 9 ⅜ x
7 ¼ inches. The Randall
Family Collection.

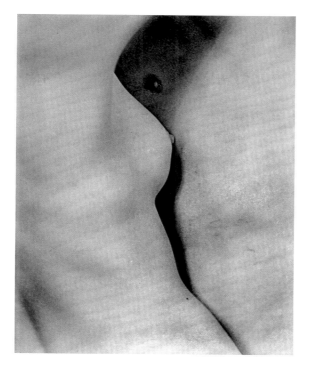

Stieglitz had begun moving
this way in his own work by
around 1907; he was par-
ticularly interested in exploring
avant-garde ideas about pic-
toral space in his compositions.
Strand began exhibiting work at
Stieglitz's 291 Gallery in 1917.
He rejected the handwork and
other painterly effects common
to pictorialism and pursued
simple, direct images of urban
subjects, such as fences, light
poles, and other mundane ele-
ments of modern cityscapes (fig.
1.16), sometimes pushed to the
edge of abstraction. Strand also
created a series of intense close-
up portraits that forced direct
and detailed consideration of the faces of his sitters. (fig. 1.17)

FIGURE 1.15.
VIRNA HAFFER,
Dedication, circa 1934.
Gelatin silver print, 11 x 14
inches. Collection of the
Washington State Historical
Society, gift of Virna Haffer,
1974.35.12.8.

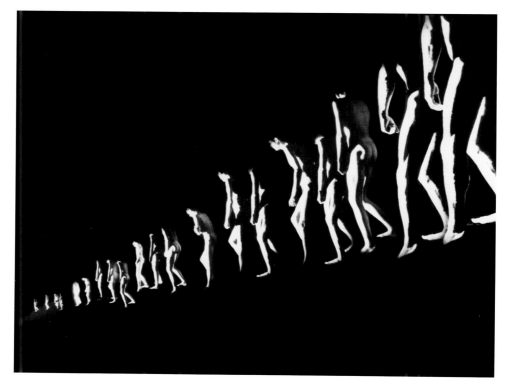

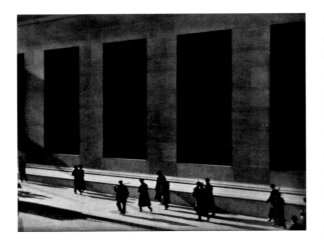

FIGURE 1.16.
PAUL STRAND
(American, 1890–1976),
New York (Wall Street),
from *Camera Work*
No. 48, October 1916.
Photogravure, 5 ³/₁₆ x
6 ⁷/₁₆ inches. Minneapolis
Institute of Arts, Gift of
Julia Marshall, 69.133.46.2.

Other prominent advocates of straight photography included Clarence H. White (1871–1925) and Edward Weston (1886–1958). White established a photography school where the students regularly took trips out into the surrounding community looking for subjects in the everyday. A number of important figures in American documentary and modernist photography studied with him, including Margaret Bourke-White (1904–1971), Laura Gilpin (1891–1979), and Dorothea Lange (1895–1965). Edward Weston believed that photographs should be sharply focused, hard-edged, and objective. He relied on dramatic close-ups, cropping, and lighting to shift perceptions of ordinary objects. (fig. 1.18) A group of like-minded West Coast photographers also embraced these ideas and called themselves Group f.64 for the smallest aperture opening on the camera lens.

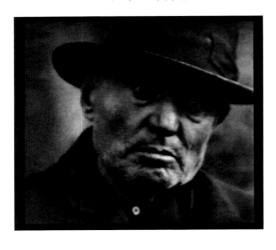

FIGURE 1.17.
PAUL STRAND
(American, 1890–1976),
*Photograph-New York
(Man, Five Points Square,
New York)*, from *Camera
Work* No. 49/50, June
1917. Photogravure, 6 ¹¹/₁₆ x
7 ⁷/₁₆ inches. Minneapolis
Institute of Arts, The
William Hood Dunwoody
Fund, 64.34.50.5.

Paralleling the growing interest in straight photography was the documentary movement in American photography. Two prominent practitioners, Jacob Riis (1849–1914) in the 1890s and Lewis Hine (1874–1940) in the 1910s, began using photography to document conditions among America's immigrant populations and in the country's manufacturing plants. Their works set the standard for using photography as a documentary and sociological tool. Both created straightforward, unsentimental images that allowed viewers to see these environments in detail, the images all the more powerful for their neutral, reportorial tone. Though titles for these images were generally descriptive and spare, Hine combined images and text in posters and pamphlets to draw attention to important social causes. This kind of imagery also strongly appealed to worker's rights organizations committed to exposing urban poverty and unsafe working conditions for American laborers. The Photo League, a group active in New York in the 1930s and 1940s, was organized specifically to document these kinds of issues; members Lewis Hine and Paul Strand were joined by a new generation of photographers, including Ansel Adams (1902–1984), Richard Avedon (1923–2004), and Lisette Model (1901–1983). Documentary photography was further confirmed

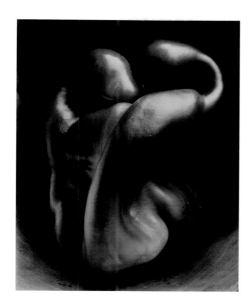

as an effective sociological tool during the 1930s when the Farm Security Administration (FSA) organized a photography bureau to document the depredations of the Dust Bowl on America's farmers, the economic and social effects of the Great Depression, and the lifestyles, towns, and traditions slowly disappearing as American society changed and populations shifted.

Virna Haffer was intrigued by both the modernist and documentary impulses in American photography. She had long been an avid taker of snapshots, recording trips, special events, and family gatherings with a natural bent toward documenting everyday life. In some images she combined a pictorialist aesthetic with documentary subjects, most notably her images of a homeless camp in Seattle taken around 1935 (see page 37 and fig. 2.24, page 57). Her most impressive body of documentary work is a series of photos taken during trips to Alaska in 1938 and 1939. The pictures range from stunning landscape studies to photos of Alaskan village life and scenes from the mines. (fig. 1.19; see also figs. 3.54, 3.55, and 3.56, page 119) Unmanipulated, unposed, and lit with natural light, the Alaska pictures and others from her travels (figs. 1.20 and 1.21) reveal Haffer's confident grasp of the documentary aesthetic. (fig. 1.22)

Haffer already had been playing with depth of space, cropping, and other devices common to straight photography, but she was less interested in the industrial and urban subjects of artists like Strand or Stieglitz with one notable exception: bridges. Haffer was fascinated by the structural elements of bridges, particularly the abstract patterns and shapes they created. Images of bridges can be found throughout her body of work, in a variety of settings (fig. 1.23), and in every style. (fig. 1.24; see also figs. 3.5 and 3.16, pages 89 and 96)

In the 1950s and 1960s the art world was shaken by radical new ideas about the definition of art. Familiar subjects, techniques, and materials were rejected or tested, pushed, and redefined. Art could be simply about itself—the act of creation—or could convey emotional, personal, political, or social content. In addition to traditional materials, such as paint or bronze, artists could create works from found objects, ephemeral natural substances, or industrial products. Boundaries between media slipped and dissolved.

It is during this period of artistic experimentation that Haffer's own work shifted dramatically to an emphasis on camera-less photographic processes, particularly

FIGURE 1.19.
VIRNA HAFFER,
White Man's Raven, circa
1938. Gelatin silver print,
19 ½ x 15 ⅞ inches.
Collection of the Washington
State Historical Society, gift
of the estate of Virna Haffer,
1974.35.12.22.

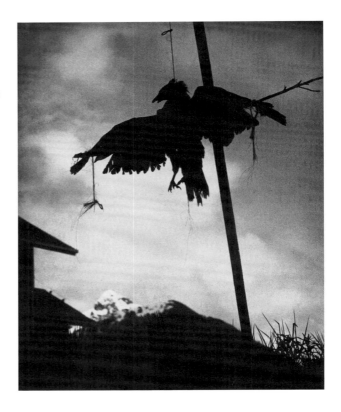

FIGURE 1.20.
VIRNA HAFFER,
Montana Scene, circa 1959.
Gelatin silver print,
9 ⅞ x 11 ½ inches.
Collection of the
Washington State Historical
Society, gift of the estate of
Virna Haffer, 1974.35.11.16.

FIGURE 1.21.
VIRNA HAFFER,
Injured Miner, circa 1938.
Gelatin silver print,
17 ¼ x 16 inches. Collection
of the Washington State
Historical Society, gift of
the estate of Virna Haffer,
1974.35.12.49.

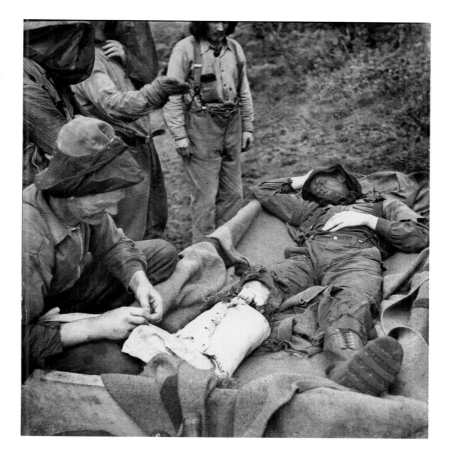

FIGURE 1.22.
VIRNA HAFFER,
Crossroads in Culture, circa
1960. Gelatin silver print,
15 x 16 inches. Collection
of the Washington State
Historical Society, gift of
the estate of Virna Haffer,
1974.35.12.4.

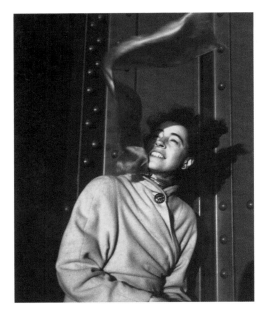

photograms. These new forms of creation were to occupy and fascinate her for the remainder of her career, and because of the innovative new methods she invented for producing photograms, she is considered one of the master practitioners of the process. Her book *Making Photograms: The Creative Process of Painting with Light*, published in 1969, remains the primary reference text on the subject.

Photograms have their roots in the earliest photographic experiments, most notably those of William Henry Fox Talbot (1800–1877) in 1839. Talbot placed ordinary objects on paper coated with photographic chemicals and exposed the combination to light so that the objects left white outlines on the paper. This technique was revived by Christian Schad (1894–1982) in 1918 then taken up in the 1920s by Man Ray and László Moholy-Nagy, who was the first to label them "photograms." Both Ray and Moholy-Nagy took Talbot's experiments further by layering objects and using collage elements and other techniques to add depth and interest.

Haffer used the basic photogram technique in a number of works (fig. 1.25), but her experiments show that she was determined to figure out how to add detail, spatial depth, and narrative content to her works. She ultimately invented a setup using layers of glass plates. (see fig. 2.33, page 64) Placing objects on different layers added depth. Objects could be moved, added, or removed and then the whole re-exposed; layers could be exposed for different lengths of time and at different light intensities. This system

FIGURE 1.25.
VIRNA HAFFER, *Flying Fish of Largo Ribera*, circa 1965. Photogram, 10 ⅞ x 13 ¾ inches. Collection of the Washington State Historical Society, gift of the estate of Virna Haffer, 1974.35.12.16.

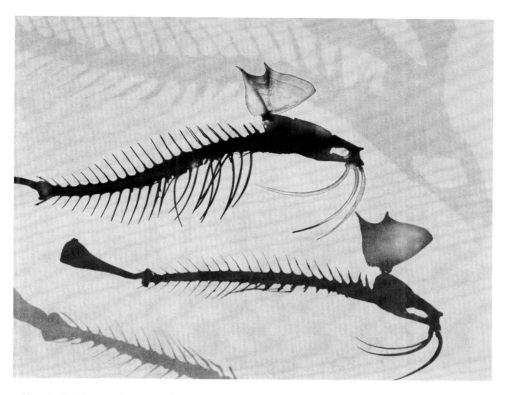

offered Haffer an almost infinite variety of ways to create, and the resulting body of work is highly diverse. (figs. 1.26 and 1.27)

FIGURE 1.26.
VIRNA HAFFER, *Funny Face* (also known as *Happenings*), circa 1968. Photogram, 19 ¾ x 15 ⅜ inches. Collection of the Washington State Historical Society, gift of the estate of Virna Haffer, 1974.35.12.56.

Haffer created a number of abstract images by placing cellophane and water in the film carrier of her developer, moving it around until a biomorphic form emerged, then exposing the resulting shape. After development, the images were reversed to obtain the final print.

The objects and materials Haffer used to create her photograms were equally varied. She enthusiastically adopted the found-object aesthetic of the 1950s and 1960s in assembling her images. She used a hodge-podge of everyday items, natural specimens, and detritus: clock parts, plastic netting, fly wings, mouse skeletons, perfume bottles, paper cutouts, plants, artificial snow, string, dried beans. Anything that came to hand could be transformed by Haffer's imagination into a subject for art.

Some of her most beautiful photograms are those she made from plants and insects (fig. 1.28). Haffer was deeply interested in the natural world and published a number of essays that paired her poems about nature with her photograms. Her house had an extensive and much-loved garden, and she carefully researched every specimen she gathered, taking them to the Washington Agricultural Station or sending them to the Washington State University Botany Department to have them identified by their scientific names. In both her photographs and photograms, by either focusing tightly on the object or enlarging the negative, she drew attention to the geometric patterns of a flying ant's wing or the myriad legs of a millipede. (figs. 1.29 and 1.30) These images are directly related to the work of photographers such as Edward Weston and Imogen Cunningham (1883–1976), who used extreme close-ups to draw out patterns and abstractions from natural objects. (fig. 1.31)

FIGURE 1.27.
VIRNA HAFFER,
Internal Fixation, circa 1965.
Photogram, 19 ¾ x 16
inches. Collection of the
Washington State Historical
Society, gift of the estate of
Virna Haffer, 1974.35.12.39.

Haffer also created a number of photograms that had personal, social, or political content. She paired some of them with texts that described her fears about the fate of the planet, nuclear war, and other social ills. It is also during this time that Haffer mentions "equivalents," a term first used by Alfred Stieglitz to describe a series of his cloud studies that he felt corresponded to inner spiritual and emotional states. This concept was revived in the late 1940s by photographer Minor White (1908–1976), from whom Haffer took a class in 1967. There are groups of her photograms that certainly have symbolic or spiritual power. One series, titled

FIGURE 1.28.
VIRNA HAFFER,
Rattlesnake Grass, circa
1960–69. Photogram,
13 ¾ x 10 ¼ inches. Tacoma
Art Museum, Gift of John
Butler, 2007.46.1.

FIGURE 1.29.
VIRNA HAFFER, *Flying Ant's Wings*, circa 1965. Photogram, 13 ⅝ x 9 ½ inches. Collection of the Washington State Historical Society, gift of the estate of Virna Haffer, 1974.35.12.24.

FIGURE 1.30.
VIRNA HAFFER, *Diplopoda*, circa 1968. Photogram, 13 ¾ x 11 inches. Collection of the Washington State Historical Society, gift of the estate of Virna Haffer, 1974.35.12.53.

FIGURE 1.31.
IMOGEN CUNNINGHAM (American, 1883–1976), *Aurelia*, 1955. Gelatin silver print, 13 ⅝ x 11 ⅜ inches. George Eastman House, International Museum of Photography and Film, 1977:0760:0026.

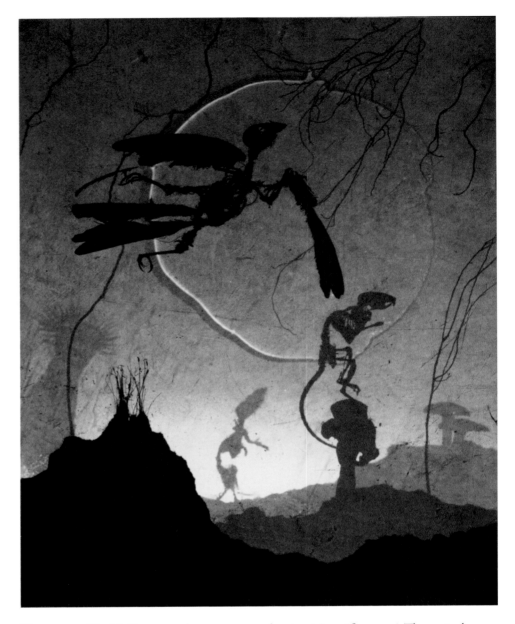

Tomorrow World, illustrates her post-apocalyptic vision. (fig. 1.32) These stark, poignant images show a blasted earth haunted by skeletal monsters and fields of gravestones—a terrifying, nightmarish view. Haffer's true power lies in the fact that she created these images from the most non-threatening of objects: paper cutouts, doll furniture, a dead mosquito, the skeletons of small animals. (fig. 1.33)

Though photograms occupied much of her time during the last decades of her career, Haffer also experimented with a variety of other processes and materials. Using a pen flashlight and photo-sensitive paper she created drawings with light and also

used developer as a drawing medium. (fig. 1.34) She spread water on sheets of cellophane, pushed it around to create interesting shapes, photographed them, then reversed them out. The resulting images are otherworldly, reminiscent of something seen through a microscope. (see fig. 1.26) During the late 1960s she also photographed historical moments on her new TV, creating her own photo-documentation of events she couldn't experience directly.

Virna Haffer's photographic work is staggering in its volume, diversity, and range of styles and techniques. Her restless creative spirit kept her in pace with the constantly shifting interests in the newly developing field of photography. She embodied the modern spirit: ever questioning, embracing her time and place, open to experimentation. Haffer's role in and impact on the Northwest photographic community is just beginning to be uncovered and understood. Notably, though little addressed in this catalogue, her commercial practice was as extensive as her artistic work and oftentimes as interesting. Haffer was extremely commercially savvy, putting herself out for hire wherever she traveled and maintaining a flourishing portrait studio in Tacoma for more than thirty-five years. Though many of these images are straightforward portraits, when clients were willing she brought some of her experimental techniques into play, including dramatic lighting, cropping, elongation, and surface toning, among others. As well, Haffer's extensive network of relationships with photographers, artists, dancers, musicians, and other creative types in the Puget Sound region (detailed in the two other essays in this catalogue) are exciting new discoveries and reveal a Northwest arts community in the first half of the twentieth century that was rich, stimulating, collaborative, and deeply intertwined.

It is the nature of art history survey texts to select and focus on a few prominent figures among the many artists active in every era and style. It is the role of exhibitions and catalogues such as this one to fill out that record in more detail by acknowledging and celebrating regional artists whose work was of equal importance but less visible. Virna Haffer's turbulent lens reflected back the tumultuous growth of a new medium in the early twentieth century. In echoing and recording its many variations she left a photographic legacy unrivaled in its depth and scope in the Northwest.

NOTE

References consulted for this essay include the following: Michel Frizot, ed., *A New History of Photography* (Köln: Könemann Verlagsgesellschaft, 1998); Vicki Goldberg, ed., *Photography in Print* (Albuquerque: University of New Mexico Press, 1981); Christina Strang Henderson, "Virna Haffer: Regional Artist and Photographer," (master's thesis, Reed College, Portland, Oregon, 2007); Mary Warner Marien, *Photography: A Cultural History* (New York: Harry N. Abrams, 2002); Miles Orvell, *American Photography* (Oxford: Oxford University Press, 2003); Naomi Rosenblum, *A World History of Photography* (New York: Abbeville Press, 1989); John Szarkowski, *Photography Until Now* (New York: The Museum of Modern Art, 1989); Alan Trachtenberg, *Reading American Photographs* (New York: Hill and Wang, 1989).

Also consulted were the Haffer archives at the Washington State Historical Society in Tacoma, the Tacoma Public Library, and the Randall family's archives.

FIGURE 1.34.
VIRNA HAFFER,
Untitled, circa 1955.
Developer drawing on
photosensitive paper,
9 ½ x 7 ½ inches.
Collection of the
Washington State
Historical Society, gift
of the estate of Virna
Haffer, 1974.35.12.25.

GALLERY ONE

PORTRAITURE

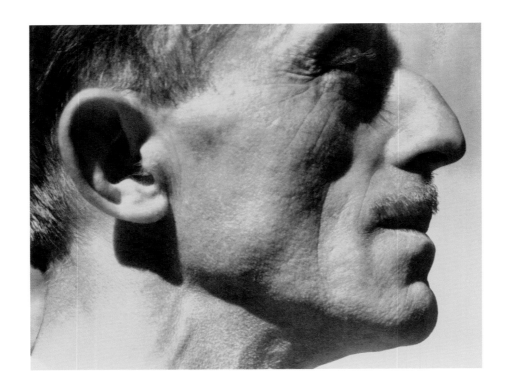

Top:
VIRNA HAFFER, *Rolf
Pielke, Los Gatos,*
circa 1932. Gelatin
silver print, 7 ¾ x 9 ½
inches. Collection of
the Washington State
Historical Society, gift of
the estate of Virna Haffer,
1974.35.12.34.

Bottom:
VIRNA HAFFER, *Eskimo,*
circa 1938. Gelatin silver
print, 9 ⅞ x 7 ⅞ inches.
The Randall Family
Collection.

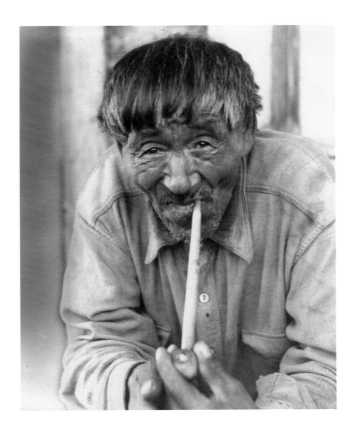

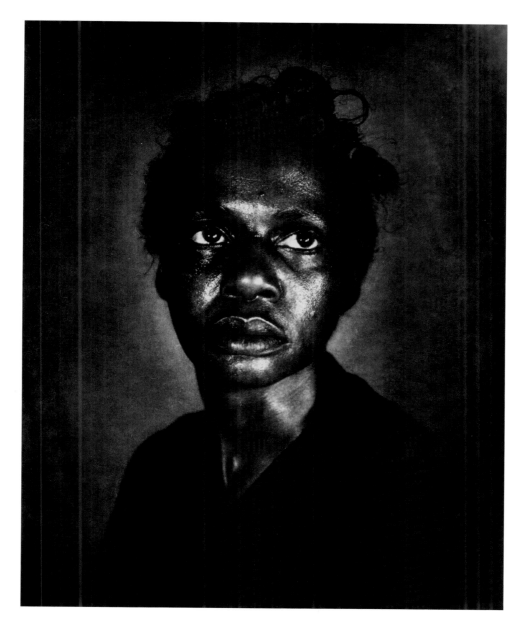

VIRNA HAFFER, *Celia*, circa 1960. Gelatin silver print, 19 ¾ x 16 inches. Collection of the Washington State Historical Society, gift of the estate of Virna Haffer, 1974.35.12.48.

For this print, Haffer accentuated the background with retouching using pencil dust and a stomp and printed it with a charcoal screen.

VIRNA HAFFER, *Franz Brasz, The Artist*, circa 1937. Gelatin silver print, 13 ¼ x 10 ¼ inches. Collection of the Washington State Historical Society, gift of the estate of Virna Haffer, 1974.35.51.3.

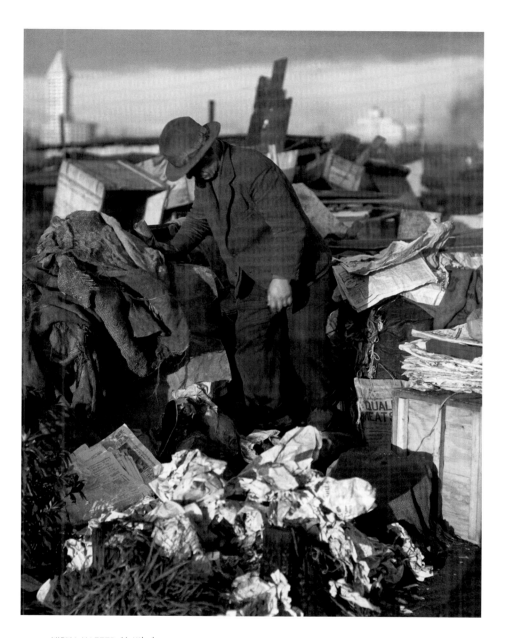

VIRNA HAFFER, Untitled
(Hooverville series), circa
1935. Scanned from the
original negative, scan file
restored and printed by Tod
Gangler. Collection of the
Washington State Historical
Society, gift of the estate of
Virna Haffer, 1974.35.10.941.1.

Top left: **VIRNA HAFFER**, *Wilbur McCormack*, 1939. Scanned from the original negative. Collection of the Washington State Historical Society, gift of the estate of Virna Haffer, 1974.35.10.1657.1.

Top right: **VIRNA HAFFER**, *Frank Delmar*, 1939. Scanned from the original negative. Collection of the Washington State Historical Society, gift of the estate of Virna Haffer, 1974.35.10.1659.1.

Bottom: **VIRNA HAFFER**, *Johnny Schubert*, 1939. Scanned from the original negative. Collection of the Washington State Historical Society, gift of the estate of Virna Haffer, 1974.35.10.1656.1.

Johnny Schubert, Wilbur McCormack, and Frank Delmar were members of the *Ted Shawn and His Men Dancers* troupe. They performed in Tacoma in 1939 and were photographed by Haffer at her studio with other prominent members of the company.

In 1933 Ted Shawn had assembled a group of young male athletes and trained them in the art of modern dance. He was trying to present a new masculine persona to change the public's perception of male dancers as being predominantly effeminate. Shawn and his men developed the legendary Jacob's Pillow dance school and performance center in the Berkshires where they lived communally, built many of the structures, and grew their own food. It remains active as one of the country's leading dance centers to this day. Other members of the dance company included Barton Mumaw, John Delmar (twin brother of Frank) and Fred Hearn. Most of the dancers served valiantly in the military during World War II and Schubert, the youngest member, was killed in action over Germany in 1943.

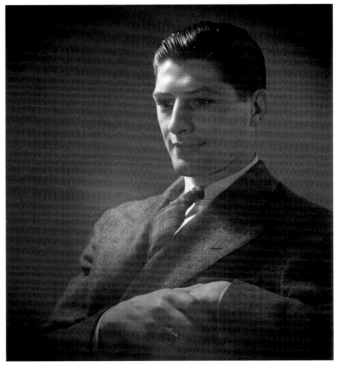

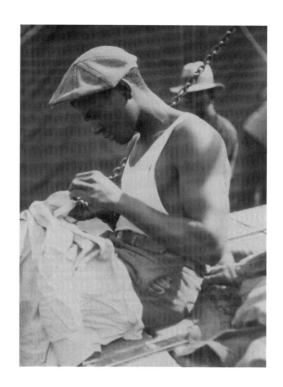

Above:
VIRNA HAFFER,
Mr. Moritz, circa 1946.
Gelatin silver print, 10 ½ x
8 ¼ inches. Collection
of the Washington State
Historical Society, gift of
the estate of Virna Haffer,
1974.35.12.35.

Top right:
VIRNA HAFFER, Untitled,
circa 1935. Scanned
from the original
negative. Collection of
the Washington State
Historical Society, gift of
the estate of Virna Haffer,
1974.35.10.1196.2.

Bottom:
VIRNA HAFFER, *Don of
Taos*, circa 1930. Gelatin
silver print, 12 ¾ x 10
inches. Collection of the
Washington State Historical
Society, gift of the estate of
Virna Haffer, 1974.35.12.14.

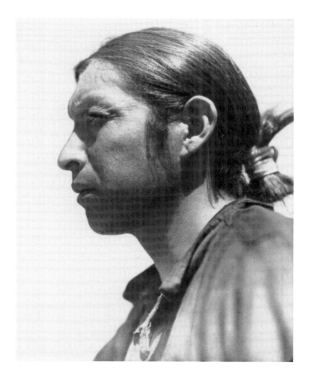

Top:
VIRNA HAFFER, *Tilley-O*, circa 1928. Gelatin silver print, 7 ⅞ inches diameter. The Randall Family Collection.

Bottom:
VIRNA HAFFER, *Self Portrait*, circa 1960. Gelatin silver print, 9 ¹⁵⁄₁₆ x 8 inches. Collection of the Tacoma Public Library.

"I greased my face with vaseline then put the paper on my face and patted as best I could to get all in contact. As I developed it I turned on the overhead light and developed to full black."

Top:
VIRNA HAFFER, *Marty*, circa 1940. Gelatin silver print, 13 ⅞ x 12 ¾ inches. Collection of the Washington State Historical Society, gift of the estate of Virna Haffer, 1974.35.12.42.

Bottom:
VIRNA HAFFER, Untitled, not dated. Gelatin silver print, 14 ¼ x 10 ¾ inches. Collection of the Washington State Historical Society, gift of the estate of Virna Haffer, 1974.35.12.6.

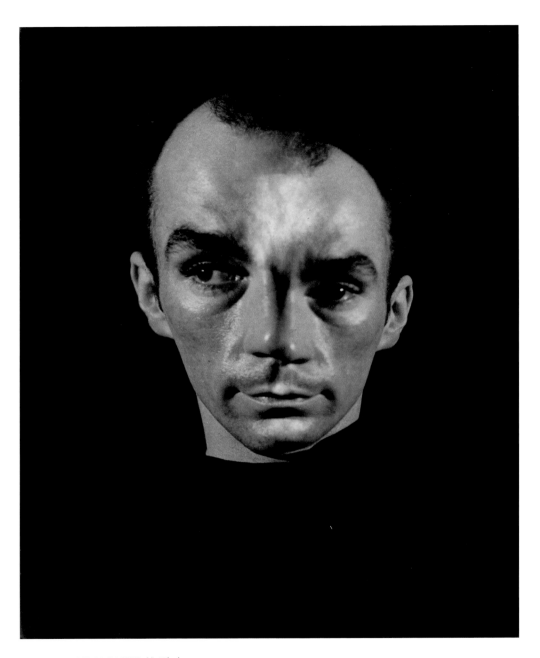

VIRNA HAFFER, Untitled
(Newell Griffith), circa 1935.
Gelatin silver print, 9 ¹⁵⁄₁₆ x
7 ¹¹⁄₁₆ inches. Collection of
the Tacoma Public Library.

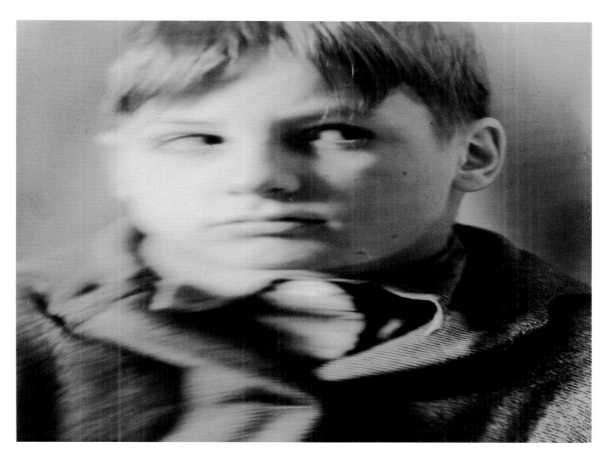

VIRNA HAFFER, Untitled
(Jean Haffer), circa 1929.
Gelatin silver print, 3 ⅝ x
4 ½ inches. Collection
of the Washington State
Historical Society, gift of
the estate of Virna Haffer,
1974.35.11.3.12.1.

Haffer produced this
distorted portrait of
her young son Jean by
photographing his reflection
in a concave mercury
glass reflector from an old
kerosene lamp.

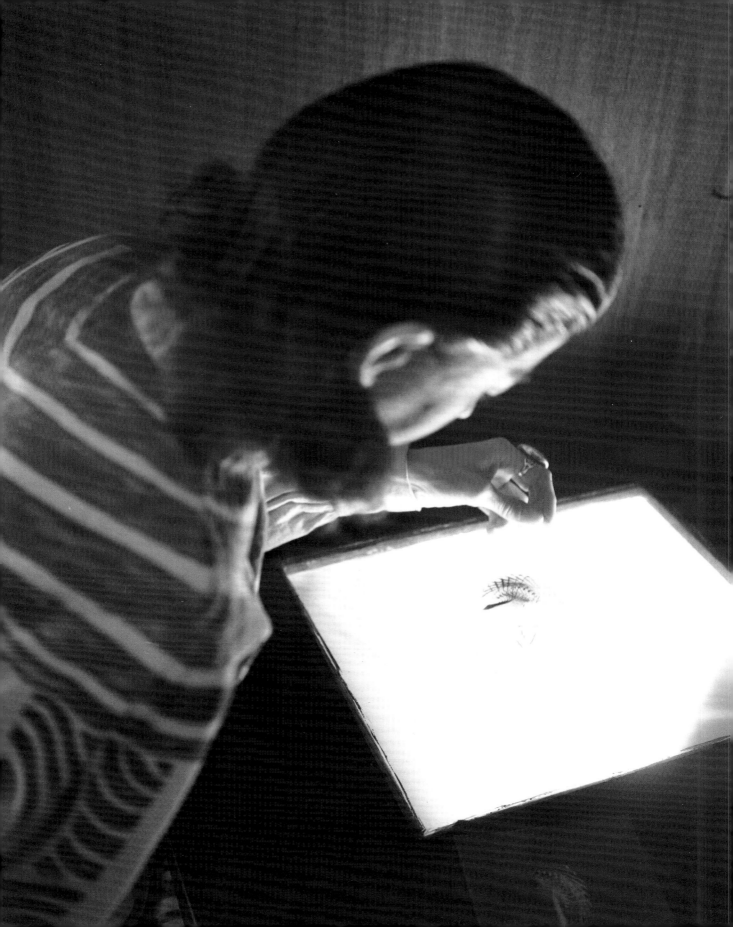

VIRNA HAFFER

THE RADICAL LIGHT

Christina S. Henderson

The ultimate success in life is when one's work becomes as compelling a force as a hobby. I think photography. I live photography. I love photography.
— Virna Haffer[1]

WITH AN UNFLINCHING EYE and an individualist spirit, Tacoma artist Virna Haffer became one of the most inventive artists in the Pacific Northwest region. In a career spanning more than six decades, Haffer found success as a photographer, printmaker, painter, musician, sculptor, and published writer, though she is known first and foremost as an artist of photography. Self-taught, she began her ambitious career in the early 1920s, using pictorial artistry to make painterly photographs and unique portraiture, which provided Haffer with her own income her entire career. Some 30,000 of her photographic negatives, prints, and woodblocks are housed at the Washington State Historical Society and Tacoma Public Library's Special Collections, and her collection of paintings and sculptures resides with her family.[2]

Although she lived on the "geographical fringes" of the art world, Haffer reached international prominence at the salon exhibition level—at the time the highest competitive class of photography—with her exceptional examples of portraiture and creative pictorial photography. In the 1960s, the last full decade of her life, Haffer abandoned the classical genres of photography—and even the camera itself—to resurrect the older, primitive art form that used only photographic materials and light, a technique called photograms. This type of camera-less photography was a radical departure from the visual work of her contemporaries. In spite of over three hundred salon acceptances for her "conventional" works, it was her unconventional art form—her photograms—that won Haffer her highest praise. Her photograms remain in the prestigious permanent collections of the Metropolitan Museum of Art in New York; the Addison Gallery of American Art in Andover, Massachusetts; and the Autry National Center in Los Angeles, California. Her inventiveness with this unusual art form earned Haffer passages in various chronicles of women innovators in photography.[3] The unconventional was no stranger to Haffer. Her long and

Virna Haffer in her studio experimenting with image overlays, circa 1934. Scanned from the original negative. Collection of the Washington State Historical Society, gift of the estate of Virna Haffer, 1974.35.10.1871.1.

productive life as an artist began with her unorthodox upbringing in the anarchist colony of Home, Washington. It was there she would experience her first exposure to photography and the arts.

EARLY YEARS

Virna May Hanson was born in Aurora, Illinois, on April 17, 1899, to professional printer and labor union organizer Henry C. Hanson and teacher Fannie E. Wooten. Henry, the son of Norwegian immigrants, met and married the spirited Fannie Wooten, a native of Nashville, Tennessee, six or seven years his junior, on November 22, 1895, in Humphreys County, Tennessee. They left middle Tennessee and migrated north, where Henry Hanson worked for IOH Stationery Printing Company. Both Henry and Fannie were politically minded and sought a community that shared their personal views and allowed a particular type of lifestyle, so in 1907 they moved their two young daughters, eight-year-old Virna May and her younger sister, Mildred, to the utopian community of Home Colony, located on Joe's Bay in South Puget Sound, Washington. (figs. 2.1, 2.2, and 2.3)

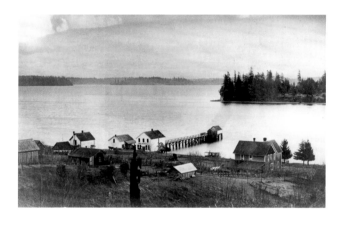

FIGURE 2.1. Photographer unknown, Partial view of Home Colony and Joe's Bay (looking south), circa 1905. Gelatin silver print, 6 x 9 ⅝ inches. Collection of the Washington State Historical Society, 1985.58.2.3.

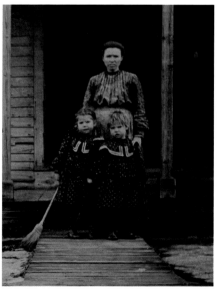

FIGURE 2.2. Photographer unknown, Fannie, Virna, and Mildred Hanson, Aurora, Illinois, circa 1903–04. Gelatin silver print, 5 ⅝ x 4 inches. The Randall Family Collection.

Home Colony, once described by its critics as the "hotbed of anarchy and free-love," was an anarchist colony founded on the principle that individual rights should reign supreme, and that all could live in harmony if government and laws were abolished.[4] Haffer's upbringing at Home had a decisive influence on her life. When asked in an interview how they thought their mother acquired her free-spirited nature, Gene and Lillian Randall, Haffer's only son and daughter-in-law, answered without hesitation: "Home!—she was raised at Home!"[5] In this primitive yet progressive, isolated yet cosmopolitan community she developed a sense of self-reliance and a strong work ethic, a keen intellect, an unconventional political philosophy, and most importantly, her passion for art and photography.

When Haffer and her family arrived by steamer at Home (fig. 2.4), the colony featured a diverse population; different European nationalities, anarchists, communists, socialists, women who campaigned for emancipation, labor reformers, free-love practitioners, misfits, and crusaders all lived at Home.[6] The Hanson family arrived to primitive conditions and built their own house, or "shack" (as Fannie called it). Haffer shared in the responsibility for the financial welfare of the family. What they lacked in amenities (no running water, no roads, and electricity wouldn't come to Home until 1926), they made up for in educational, political, and cultural activities.

Home Colony's brand of anarchy was the "freedom to make oneself."[7] Education, the great social equalizer and means to self-realization, was the focus for all Home Colony inhabitants—young and old. Every house was full of books. Haffer's formal education included a self-selected curriculum in an open forum that encouraged debate and self-directed learning. Haffer took from it the freedom to debate and the freedom to challenge convention. Visitor Elbert Hubbard, philosopher, artist, and founder of the Roycroft colony in New York, said of his experience in Home that he "had never seen a more intelligent lot of men and women."[8] (fig. 2.5)

Political and cultural activities enjoyed a full docket. Haffer's parents raised her to be an independent thinker and decision maker and included her in adult activities of the community.[9] As a result, Haffer was exposed to the great debates and lectures by visiting political and cultural activists like Elizabeth Gurley Flynn, founding member of the ACLU; organizer for the Industrial Workers of the World William Z. Foster, a labor organizer, Marxist, and general secretary of the Communist Party

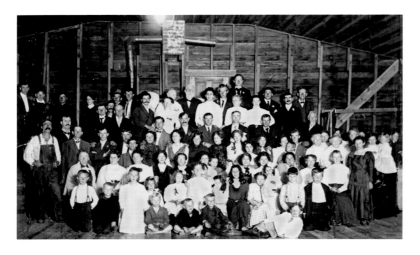

USA; women's rights activist Emma Goldman; and Margaret Sanger, activist and founder of the American Birth Control League.[10] This exposure offered intimate and unique access to significant newsworthy events of the day and would influence the sympathies she took into adulthood for emancipation of the worker and labor issues, the plight of the poor, cooperative living, and women's sexual freedom. These ideals are reflected in some of her later visual imagery.

FIGURE 2.5.
Photographer unknown, Home Colony members in Liberty Hall (including Virna Haffer, second row, fourth from left), circa 1910. 9 ⅝ x 13 inches. Collection of the Washington State Historical Society.

"Home is a community of free spirits who came out into the woods to escape the polluted atmosphere of priest-ridden, conventional society."
Jay Fox, Editor, *The Agitator* (1910–1912). Excerpt from "The Nude and the Prudes," July 1, 1911.

Haffer's life in Home was not restricted to hard work and study. One Home resident said, "School was out and off came the shoes. There were campfires on the beach, and hours of playing 'fox and the geese.'"[11] (fig. 2.6) Pranks were high on the list of entertainment. Music, too, was a mainstay. It was a very important part of life in Home, and the people of Home Colony themselves formed a number of brass bands over time. Haffer herself became a skilled pianist and clarinetist and would be a professional player of the saxophone with the Hollywood-based dance orchestra the Jazzetts. (figs. 2.7 and 2.8)

FIGURE 2.6.
Photographer unknown, Untitled (Haffer in a bathing suit), July 4, 1921. Gelatin silver print, 5 ¼ x 3 inches. Collection of the Washington State Historical Society, gift of the estate of Virna Haffer, 1974.35.11.5.4.1.

Haffer encountered the arts at a very early age. (fig. 2.9) Her talent for composition and drawing strongly suggests an early exposure to the fundamentals of painting and drawing. More importantly, a serendipitous experience with an art form that would have a profound influence on the course of Haffer's life happened at Home Colony when she was very young. When Haffer was only ten years old, a photographer came to Home Colony to take some pictures. "She was quite taken by the idea of pictures," her son recalls, and "it was then and there she decided that it [was] what she was going to do!"[12]

Eventually, Haffer's education led her beyond the borders of Home. As was the custom for the

FIGURE 2.7.
VIRNA HAFFER, Formal portrait of musician Virna Haffer with her saxophone, circa 1926. Gelatin silver print, 2 ½ x 1 ¾ inches. Collection of the Washington State Historical Society, gift of the estate of Virna Haffer, 1974.35.11.7.6.3.

FIGURE 2.8.
BOLAND STUDIOS, Virna Haffer as a Jazzett (located far left), 1926. Gelatin silver print, 7 ½ x 9 ½ inches. The Randall Family Collection.

FIGURE 2.9.
VIRNA HAFFER, Untitled (Haffer playing the piano), September 9, 1924. Gelatin silver print, 3 x 2 inches. Collection of the Washington State Historical Society, gift of the estate of Virna Haffer, 1974.35.11.5.87.3.

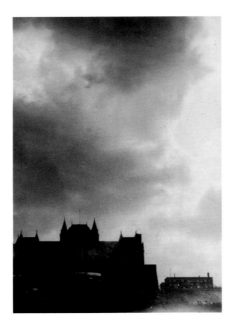

children of Home who sought a secondary education, she went off to Stadium High School in Tacoma in 1913–1914. (fig. 2.10) True to her self-reliant upbringing at Home, she lived on her own in an apartment while she attended school. At the age of fifteen and before the end of her first year, Haffer became restless to begin her life as an art photographer.[13] She began the common course for self-taught photographers—she apprenticed herself as a "handy girl," an assistant to established local photographer Harriette H. Ihrig in 1914. By 1916 she had gone out on her own as a photographer and a "retoucher"—a move that was highly un-usual for a young woman of the time.

It was during this year, at age sixteen, that she also began taking her own photographs. She arranged her photographs in albums and numbered them and their corresponding negatives to keep a registry. Haffer photographed landscapes, seascapes, interiors, floral still lives, and portraits of family members and friends from Home Colony and Tacoma. Her earliest album, photos taken before 1920, contains a variety of subject matter taken with a certain reserved politeness she possessed as a shy beginner. One can see early evidence of Haffer's attempts to become a specialist in her concentration on composition and attention to background, proportion, and

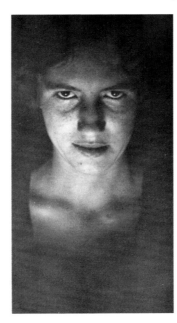

balance, and with her portraiture, a serious focus on pose and lighting. In these early works hints of the influences of pictorialism, a style of photography that used special techniques to create idealized images, can be seen in her attempts at soft focus or the use of dramatic lights and darks typical of art photography. No doubt her experience as a retoucher helped to develop her artistic eye. (figs. 2.11 and 2.12)

She felt competent and confident in her abilities as a professional photographer and made another bold move in 1919, when she opened her own photography studio in Auburn, Washington. Unfortunately, her only customer at the studio was her father, and shortly after Haffer returned to Home Colony.[14] While her professional life had stalled, her personal life was flourishing; in April of 1919, she wed the first of her three husbands, a local mechanic and motorcycle enthusiast named Clarence Edwin Shultz.[15]

FIGURE 2.13.
Photographer unknown, Untitled (Mildred Hanson, Haffer's sister, and Virna), circa 1921. Gelatin silver print, 5 ¼ x 3 ⅛ inches. Collection of the Washington State Historical Society, gift of the estate of Virna Haffer, 1974.35.11.5.7.2.

FIGURE 2.14.
Photographer unknown, Untitled, October, 1919. Gelatin silver print, 3 x 5 inches. Collection of the Washington State Historical Society, gift of the estate of Virna Haffer, 1974.35.11.8.54.2.

Haffer with her first husband, Clarence Edwin Shultz, at the destination of their journey by motorcycle to California, October 1919.

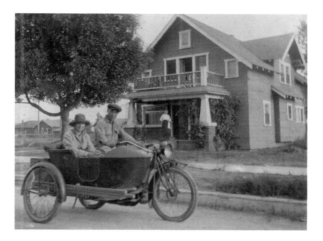

The newlyweds took off on Clarence's motorcycle and for "two months and one week" were on an adventure that took them to Los Angeles (fig. 2.14), stopping along the way to take odd jobs to pay expenses. The partnership was short-lived, however; back in Home in May of 1920, and for reasons that remain unknown, her marriage to Clarence ended.

Roaring 1920s & 1930s

Haffer returned to Tacoma and soon after met Paul Raymond Haffer, a socialist (the educational kind), labor rights advocate, and longshoreman, who would become her second husband and the father of her only child. Paul, a tall, blue-eyed, broad-shouldered man "topped by a mass of yellow, unruly bristling hair," had already made quite a name for himself.[16] In 1916, while Virna was learning the art of photography and posing her girlfriends in the sunlight, twenty-one-year-old Paul Raymond Haffer experienced a failed attempt to run for city comptroller, was charged by the State of Washington with libeling the memory of George Washington, and, while serving

time for his libel conviction, was charged with failing to register for the draft.[17] Paul Haffer's libel of our first president as an exploiter of white and black slaves, a blasphemer, user of profanity, and "an inveterate drinker," garnered national attention. Evadna Cooke, a childhood friend of Virna Haffer's for sixty-seven years and former Home Colony resident, in a personal letter to historian Mr. Charles LeWarne, stated: "Paul was an active radical then, [and] had been a C.O. [conscientious objector] in the war just ended—naturally we thot [sic] he was a hero and a martyr."[18] (fig. 2.15)

Paul and Virna married sometime between 1921 and 1922. Their first place was on North 1st Street in Tacoma until 1923, when they moved into a home nestled among a small community of fellow socialists, artists, and friends from Home Colony on remote Stevens Street in South Tacoma. It was a small three-room framed cottage with toilet facilities that were plumbed into the back porch.

On March 28, 1923, their son Jean Paul Haffer was born; he would later change his name to Gene. (fig. 2.16) To chronicle his growth and preserve family memories, Virna bought a studio-model camera. According to Haffer, others who saw her pictures wanted pictures of their own babies just like the ones she was taking of

FIGURE 2.15.
VIRNA HAFFER, *Paul Raymond Haffer*, circa 1924. Gelatin silver print, 3 x 2 inches. Collection of the Washington State Historical Society, gift of the estate of Virna Haffer, 1974.35.11.5.138.5.

Paul Haffer was Virna's second husband.

FIGURE 2.16.
VIRNA HAFFER, *Silhouette*, September 3, 1924. Gelatin silver print, 2 x 3 inches. Collection of the Washington State Historical Society, gift of the estate of Virna Haffer, 1974.35.11.5.80.2.

Paul Haffer with their son Jean.

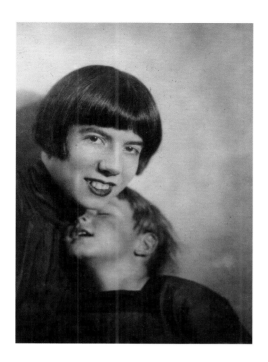

baby Jean. Her new studio career began with trading portraits of children in exchange for their parents' goods and services. At a certain point, she felt she was ready for the challenge of a portrait business again. "Finally I got the nerve to hang out my shingle and I've been at it ever since," Haffer said in an interview in 1966.[19] The small Stevens cottage would morph in appearance as she added rooms, quirky walls, and brick archways. But it would remain her official portrait photography studio for nearly fifty years, a business that would enable her to make a living and support herself and her family in the years to come. (fig. 2.17; see also page 144)

The decades of the 1920s and 1930s were ones of great artistic development for Haffer. Within a mere year after the purchase of her studio-model camera she achieved recognition as an art photographer. Haffer's career was distinguished by her first exhibition award for a portrait of a toddler titled *Fraidy Cat*, won in Seattle at Frederick & Nelson's *Salon of Pictorial Photography* in 1924.[20] (see fig. 3.6, page 90) Two of her portraits were published for the first time in the *Tacoma News Tribune and Ledger* in 1927. Haffer also joined the short-lived Seattle Camera Club in 1929, a move that had a profound effect on her artistic aesthetic, introduced her to famous photographers, and sparked friendships with Ella McBride (1862–1965) and Yukio Morinaga (1888–1968), who became a close collaborator. Her professional music career with the Jazzetts would continue through the twenties but fade away in the thirties. The Stevens Street portrait studio was first formally marketed to the public, ironically, the same year as the economically devastating stock market crash of 1929 and would prove to be financially successful, providing her with the means to travel, take care of her young son, and hire her own assistant. It also meant she was not dependent upon any government-sponsored art projects for living wages. Her studio's success allowed her the flexibility to wander into the domain of experimental photography. By 1930, she had been identified in *The American Annual of Photography* as one of the most recognized pictorial photographers in America. Haffer was elected to membership in the Print Club of Philadelphia on the merits of six woodblock prints. She exhibited over fifty block prints in the late twenties and early thirties and continued the art form, but eventually creative photography overtook block prints as her primary means of artistic expression.[21] (see pages 82 and 83)

On the afternoon of October 17, 1930, Virna Haffer, "simply dressed in pale green crepe," greeted over one hundred Tacoma women as they gathered in the lounge at

the Winthrop Hotel for her first of four annual shows in Tacoma.[22] While sipping tea, the women studied block prints titled *War, Peace,* and *The Big House.* Next to charming, artistic portraits of young children and babies with titles such as *Tootsies, His First Growth, Robert,* and *Boy Blowing Bubbles* hung daring photographs of naked men. (see figs. 3.8, 3.29, and 3.31, pages 91, 104, and 106) The juxtaposition of Haffer's beautiful impressionistic photographs presented side by side with those displaying shocking subject matter and unusual technique were evidence of her free spirit, fearless ability to take risks, and her imaginative fancy. A review of Haffer's *Winthrop Hotel Exhibition* in October 1933 encapsulates her individuality of style in treatment and approach and her power to interpret the common, which was in accord with her artistic voice and reflective of her past.

> *No review no matter how long can adequately describe this show. It is much too varied in subject matter and treatment. Virna Haffer's penetrating sense of the apt and the true, her zest for ferreting out the essence of life which moves about her, her adherence to a code which shuns artificiality and lush prettiness, makes it impossible for one to neatly tag her creations or recapture their strength in cold type.*[23]

FIGURE 2.18.
VIRNA HAFFER, Untitled (interior with son Jean), May 4, 1925. Gelatin silver print, 2 ⅜ x 3 inches. Collection of the Washington State Historical Society, gift of the estate of Virna Haffer, 1974.35.11.7.4.2.

This photograph was taken by Virna Haffer at Fannie Hanson Rogers' house in Home Colony.

The form of creative art photography that influenced Haffer's early career was pictorial photography. Pictorialism was the artistic enhancement of recognizable visual images to create unique works, and it dominated the photographic scene in America from the 1910s to midcentury. For a photograph to be considered a work of art, it had to be composed and manipulated by hand as if it were a painting. An artist using pictorial techniques would work the negative or the print by any number of methods to give it the dreamlike, romantic, or mysterious mood so desirable in an original art photograph. (fig. 2.18; see also figs. 1.6, 1.7, and 3.38, pages 17 and 110)

In portraiture, Haffer's use of composition and lighting and creation of emotional effect set her apart from other photographers of the area and attracted the social elite to her studio. Most portraitists of the time had their clients don their favorite dress or suit and posed them seated, arms folded, in a stiff-backed chair set in front of

a drape flanked by a vase of seasonal flowers. However, Haffer also strove to capture the spirit—the psychological essence of her subject—for the final print. According to Haffer, a key to her success was when photographing a subject she concentrated on the eyes rather than the smile. Many of her portraits have a painterly quality—some have the feeling of charcoal drawings, some are overexposed (solarization), and some are done as dramatically lit vignettes in homes. She continued to excel in the area of portraiture of children, somehow knowing just the right moment to push the shutter. Many of her portraits won the praise of national salon judges.[24] (see figs. 3.14 and 3.32, pages 95 and 107, and page 35)

When other art forms historically denied women access to the nude model, photography, the democratic art, allowed women to include the nude in their iconography. Haffer was captivated by the nude. Pictorialist canon suggested the nude be presented as an idealized human form with extreme simplicity and in the abstract. Haffer took advantage of the camera's ease of use and portability and photographed both male and female nudes in the studio and in strange and difficult places outside the studio. As was the case for many women photographers, Haffer used for subjects what was immediately available to her. Her nude models included her longtime friends from Home Colony, neighbors, her husbands, fellow artists, and even her son. Haffer's first known nude was taken of herself on a trip to California with Paul in 1922, set in what looks like sparsely furnished sleeping quarters. (fig. 2.19) Dr.

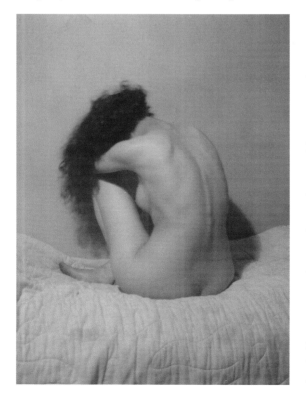

FIGURE 2.19.
VIRNA HAFFER,
Untitled, circa 1922.
Gelatin silver print,
2 ¾ x 2 inches. Collection
of the Washington State
Historical Society, gift of
the estate of Virna Haffer,
1974.35.11.5.29.1.

This is Haffer's earliest known nude.

Rose Ostroff Payne from Home Colony, internationally honored for her work in bacteriology, posed for "several nudes on the agreement [her] face would not be shown."[25]

Haffer's early nude photographs of the 1920s were soft and impressionistic, with the pubic area always slightly blurred. In the late 1930s, Haffer collaborated with her friend and poet Elizabeth "Bettie" Sale on a book titled *Abundant Wild Oats*. The illustrations for the book were done by Haffer. All nude photographs, they are very unusual and erotic, and many of them are surrealistic in feel. The

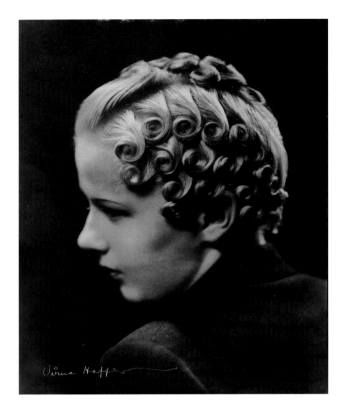

book was advertised in the Tacoma arts magazine *City of Destiny* (1938–1940), a local arts magazine to which Haffer contributed photographs. It was never published—probably being too erotic for publication at that time. (see pages 126–141)

The exotic also enchanted Haffer during the early part of her career. Three types of images—the softly focused, stylishly attired, mysterious figure, exotic peasantry, and unspoiled landscapes in foreign lands—typified much of her early salon work. She also did theatrical-type photography with dancers (the dance troupe Ted Shawn and His Men Dancers) and radio personalities (Bettie Sale), as well as glamour photographs of stylish hairdos and the high fashions of the day. Haffer's younger sister, Mildred, would become a beauty shop operator, and perhaps these photographs were inspired by or done for her. (fig. 2.20)

FIGURE 2.20.
VIRNA HAFFER, Untitled (studio portrait of hairstyle), circa 1920–1930. Gelatin silver print, 9 ⅜ x 7 ½ inches. Collection of the Washington State Historical Society, gift of the estate of Virna Haffer, 1974.35.11.18.

As a reader of the American Marxist publication the *New Masses* (1926–48), Haffer may have heeded the activist artists' call for social realism in art—art that reflected the lives of the workers and exposed social injustices. With the deepening of the Depression, Haffer captured images of the unemployed, of "Hoovervilles" (shanty towns), and of urban and rural landscapes. In 1933 an admirer wrote, "She is an American. She lives in 1933 and she is a person who has no illusions about the society from which she draws inspiration."[26] The industrialization of America also fascinated Haffer, especially the geometrical forms produced by industrial landscapes

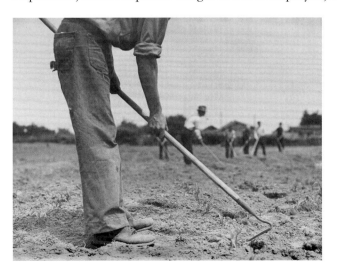

FIGURE 2.21.
VIRNA HAFFER, *Unemployed Citizens League–Gardening Division*, circa 1931. Scanned from the original negative. Collection of the Washington State Historical Society, gift of the estate of Virna Haffer, 1974.35.10.652.1.

FIGURE 2.22.
VIRNA HAFFER, *Sacco and Vanzetti Protest, Seattle, Washington,* circa 1927. Scanned from the original negative. Collection of the Washington State Historical Society, gift of the estate of Virna Haffer, 1974.35.10.816.

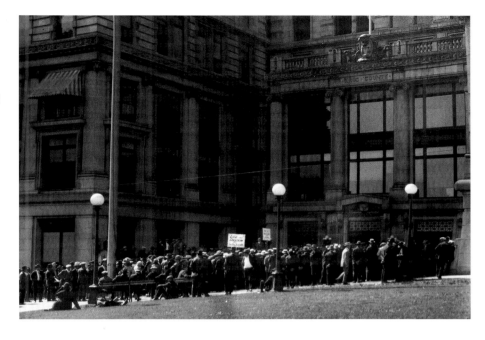

FIGURE 2.23.
VIRNA HAFFER, *Chicago Ghetto,* circa 1931. Scanned from the original negative. Collection of the Washington State Historical Society, gift of the estate of Virna Haffer, 1974.35.10.0.

This photograph was exhibited in October 1931 at Haffer's solo exhibition at the dance studio of Isabel Keith Morrison.

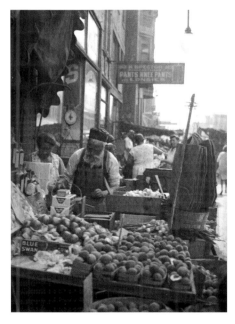

FIGURE 2.24.
VIRNA HAFFER, Untitled (Hooverville Series), circa 1935. Scanned from the original negative. Scan file restored and printed by Tod Gangler. Collection of the Washington State Historical Society, gift of the estate of Virna Haffer, 1974.35.10.941.2.

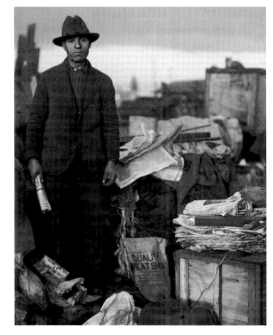

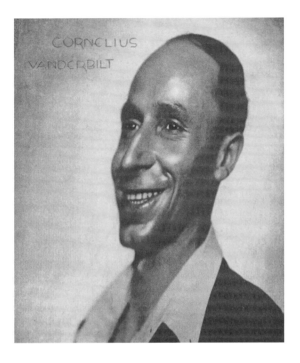

FIGURE 2.25.
VIRNA HAFFER, *Cornelius Vanderbilt*, circa 1934. Bromide print reproduced in *Camera Craft*, September 1934, and *American Photography*, January 1935. Courtesy of Martin-Zambito Fine Art, Seattle.

FIGURE 2.26.
VIRNA HAFFER, *Norman Bigelow Randall*, circa 1936. Scanned from the original negative. Collection of the Washington State Historical Society, gift of the estate of Virna Haffer, 1974.35.10.1403.1.

Norman Randall was Virna Haffer's third husband.

and bridges.[27] (figs. 2.21, 2.22, 2.23, and 2.24)

As Haffer mastered the traditional subject matter and manipulative techniques of pictorial photography, she also directed some of her energy toward transgressing those same conventions. Pictorial photography permitted a range of creative expression through technical manipulation of negatives and prints, but it was limited to certain conventions in subject matter. Haffer began creating works with subject matter that provoked a different set of responses from the onlooker. She created imagery that transported the viewer from the idealized beauty of reality to "violations of the natural order of things—constructed realities of the incredible."[28] In 1934 her award-winning salon photograph *Cornelius Vanderbilt* aroused "considerable discussion as to whether or not caricature is properly within the province of photography."[29] (fig. 2.25)

Haffer tirelessly experimented with techniques and evolved her own rules, pushing beyond the boundaries of her medium. As she became more engaged, she traveled frequently in pursuit of fresh subjects in new locales. Her photography travels began as early as her first motorcycle trip with Clarence Shultz in 1919 and continued throughout her life. In the 1920s she made frequent trips to Southern California, and in the 1930s she expanded her route to include places in the Southwest and Midwest. In 1931 Haffer and her son journeyed six thousand miles in a circuitous route that included first New Mexico and then, after some unexpected car trouble, a trip to Michigan to pick up a new Chevrolet. From there, the two made a special pilgrimage to her birthplace in Illinois and then finally headed back to New Mexico via the famous Route

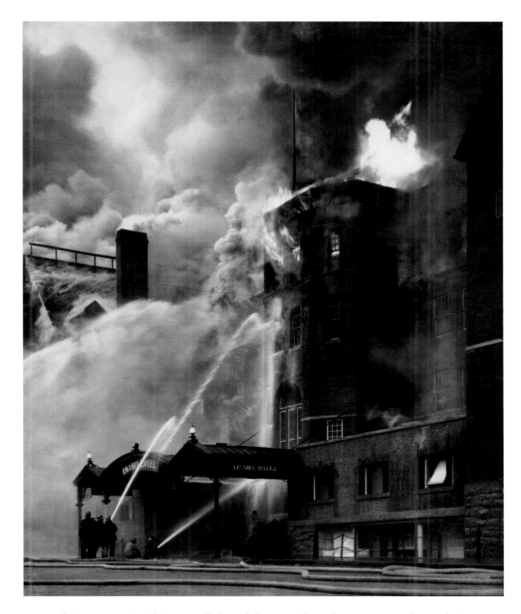

66, making a stop in Chicago, all the while recording the scenery and people in photographs. A few years later Haffer would add Mexico to her list of photography outings, a place for which she expressed great affection and which provided subject matter for many salon-quality photographs.

The 1930s proved to be an adventure in her personal life as well. Information about Paul Haffer as a member of the family disappears around 1932. However, he remained in Tacoma and continued his labor activism, and around 1937 he remarried. Haffer met her third husband, Norman Bigelow Randall, in 1935 through mutual friend Erna Tilley, a patron of Tacoma arts. (fig. 2.26) He was in town temporarily

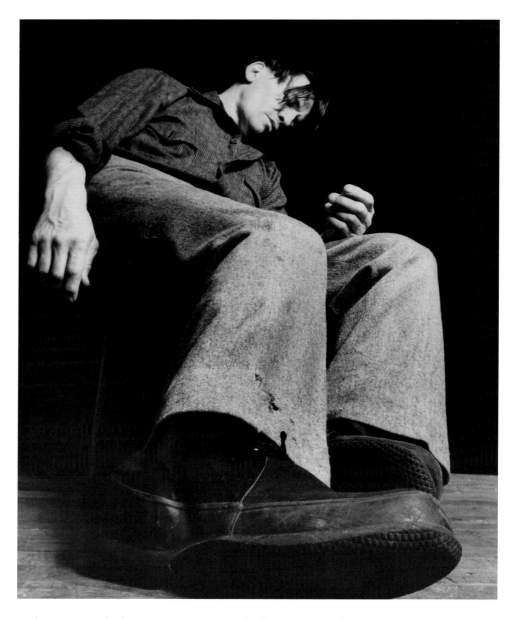

and staying at the historic Tacoma Hotel when it caught fire. He called Haffer to
come and photograph the fire, and from that point on they were a couple. (fig. 2.27)
They married soon afterward. Haffer's photographs of the burning hotel were strik-
ing and subsequently published and exhibited many times over. The bricks from the
rubble were artfully incorporated into a new facing and addition to Haffer's Stevens
Street studio and home.

An engineer, entrepreneur, artist, and adoptive father to her son, Randall would
(along with Jean) become one of her most photographed models, serving as a model
for many of Haffer's experimental photographs in the 1930s and 1940s. (fig. 2.28)

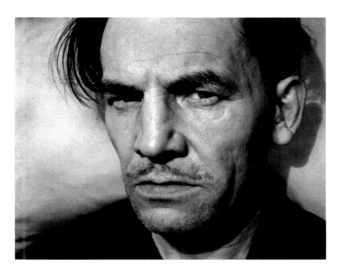

FIGURE 2.29.
VIRNA HAFFER, *Hardrock Randall*, circa 1935. Gelatin silver print, 8 ⅛ x 9 ¾ inches. Collection of the Tacoma Public Library.

FIGURE 2.30.
VIRNA HAFFER, Untitled (Self portrait with trailer), circa 1950–1960. Scanned from the original negative. Collection of the Washington State Historical Society, gift of the estate of Virna Haffer, 1974.35.10.2250.1.

Haffer's portrait *Hardrock Randall* was given first-place recognition by a San Francisco salon competition sponsored by *Camera Craft* magazine in 1936. (fig. 2.29) He also introduced her to another favorite travel destination, Alaska, where he worked as a mining engineer and where she trekked in 1938 and 1939. Haffer's pictures of Alaska are some of the most exquisite in her oeuvre. (see figs. 1.19, 3.54, 3.55, and 3.56, pages 24 and 119) She photographed the unsullied landscapes and primitive living and working conditions of its miners and pioneers. Her trip in 1939 was to photograph the natural beauty, sturdy people, and cultural settlements with friend and poet Bettie Sale, with whom she had plans for a pictorial publication on Alaska. While "roughing it" she took photographs for Randall's mining company. Sadly, Randall died suddenly in June of 1950. Haffer would remain a widow for the remainder of her life.

WAR YEARS—1940S & 1950S

In contrast to the adventuresome 1920s and 1930s, the next two decades of Haffer's life were relatively quiet but still very productive. Pictorial photography was falling out of favor and straight photography (rejecting the use of manipulation) and documentary work (social documentation born during the Depression of the 1930s) were dominating in popularity. By the mid-1950s, pictorial photography was becoming marginalized by technological developments, and its subject matter was considered passé or trite.

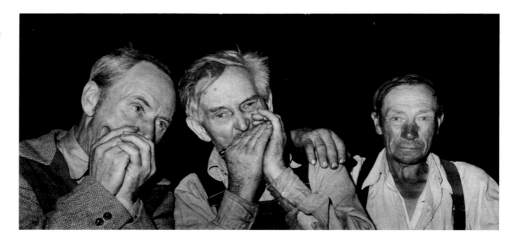

In the 1940s, Haffer spent the war years quietly engaged in the business of taking portraits of young men going off to fight in Europe and the Pacific. She was forever a utopian and a proponent of peace and was greatly affected by political events. There is also evidence of whimsical photomontages that she produced and included in her scrapbooks from this period—a precursor to creations she made later in the 1960s.

In the 1950s Haffer remained active in the photography salon culture. She produced many award-winning, sentimental, soft-toned, pictorialist portraits and romantic landscapes of exotic European locations.[30] She was also traveling south again once a year for extended periods, this time with a trailer in tow and making it as far south as Guatemala. (fig. 2.30)

In the late 1940s and 1950s Haffer bought a small cabin and photographed a little-known beach hideaway on the Tacoma Narrows called Salmon Beach. Over the years, Salmon Beach has been a fishing community, a haven for distillers of moonshine during the Depression, and a bohemian enclave. Her photographs were used as illustrations for the 2002 book *Tacoma's Salmon Beach*, part of a series called Images of America. Ralph Jenks, a resident of Salmon Beach, was the model for *Maestro*, an award-winning salon photograph from the 1950s. Likewise, the musician subjects of *Homespun Harmony* were willing models from Salmon Beach. (fig. 2.31) Perhaps this was a place of refuge for Haffer, much like Home Colony. Haffer, before her death, donated sixty color slides and a box of black-and-white photographs she had taken for the eventual publication of the book *Tacoma's Salmon Beach*.

Haffer was also able to capture the majestic beauty and historical significance of Celilo Falls in 1954, only a few years before it was buried when The Dalles Dam backed up the Columbia River. The photographs, rarely seen by the public, were very important to her given the large number of prints she produced from the nega-

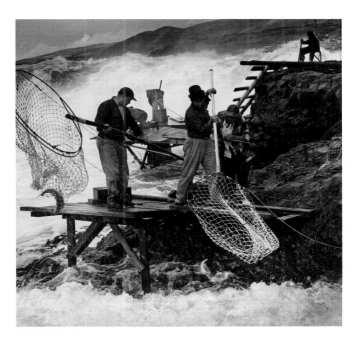

FIGURE 2.32.
VIRNA HAFFER, *Celilo Falls Fisherfolk*, circa 1954. Gelatin silver print, 12 ¾ x 13 ¼ inches. Collection of the Washington State Historical Society, gift of the estate of Virna Haffer, 1974.35.12.47.

tives. They are yet another example of her versatility as an artist, her varied interests in subject matter, and her steady, tireless work of the 1950s. (fig. 2.32)

In her scrapbook is a brochure for the *1959 Seattle International Exhibition of Photography*. Under the heading "Print Jury" is the name Virna Haffer underlined with a ballpoint pen. She had attained what many photographers ultimately desire, to have their skill and reputation recognized in a judgeship for a salon. Soon afterward, she would introduce her new photography technique, which she viewed as the ultimate outlet for creativity. Haffer's photogram, *Aftermath*, was accepted to the Victoria Camera Club's *Salon of Photography* in 1961, which suggests she was perfecting the technique during this quiet but exceedingly productive period of the 1950s.[31] (see fig. 1.33, page 31)

THE 1960S: SELF-ACTUALIZATION

The final fifteen years of Virna Haffer's life were years of innovation, recognition, and prolific output in both her photographic work and as an educator. She enjoyed the success from fourteen known invitational shows or exhibitions, most on the West Coast from Los Angeles to Tacoma, but also invitational shows in Chicago, New York, and Cambridge, Massachusetts. In July of 1960 Haffer accepted an invitation from Massachusetts Institute of Technology to show seventy of her salon-quality photographs and photograms at the M.I.T. Photo Service Gallery.[32] Haffer received twelve known awards during the 1960s, including the Chicago Photography International Salon Honor Award and a winning photograph in *Popular Photography Magazine* in 1963. In 1964 she was awarded a master of photography by the Professional Photographers of America. Her photogram *California Horizon* (see fig. 3.61, page 123) was selected for the 1965 worldwide traveling exhibition *Photography in the Fine Arts IV*, and it was eventually purchased by the Metropolitan Museum of Art and included in *The World Book Encyclopedia of Photography* (Vol. 9–10). Haffer published her book *Making Photograms: The*

Creative Process of Painting with Light in 1969, for which Jacob Deschin, the photography editor of the *New York Times* wrote the introduction. During the 1960s and 1970s, Haffer also lectured and donated her time to community arts events, judging local competitions such as the Brown's Point Salmon Bake photo contest in August of 1964.

Haffer is most recognized for her experimentation with and refinement of the art of photograms, or as she called it, "the creative process of painting with light."[33] After exhausting all possibilities with the camera and "idealized" pictorialist imagery, she turned to a form of camera-less picture making. Photograms by nature are about light and shadows produced by the shielding of light-sensitive paper by objects. Photograms offered freedom from rules and enabled her to flex her imagination and express her unique artistic vision. Her photograms ranged from the whimsical and surreal to the abstract and powerfully symbolic, and they are a dramatic departure from her portraiture. Their imagery and new technique suggest Haffer shared the concerns of many artists who had come into their own in the sixties and who broke with artistic convention and expressed their inner feelings in a variety of styles. Haffer chose in some of her pieces to use her artistic voice to communicate her concerns about nuclear war, the need for peace, and the destruction of the environment through a medium she tailored to work for her. *Aftermath*, Haffer's first sociopolitical photogram on record, is a construction from bits and pieces of commonplace items that she assembled into a dramatic narrative with a social purpose. (see fig. 1.33, page 31) She said of the photogram medium that its potential was "endless," that it was a "most flexible outlet for creativity" and "[was] almost a completely creative process"—something that suited her desire for the challenge of limitless creative possibilities. [34]

With this new inventive art form she was able to integrate her love of flora and fauna as a palette from which to work. She composed her creations from found objects of all kinds. From intricate dandelion docks, insect wings, peanuts, tomatoes, fish bones, and bird skeletons, anything was a potential subject in a Haffer creation. She was a supporter of the Tahoma Audubon Society chapter and had great respect for plant and animal life. She wrote the following for a manuscript that remains unpublished:

Homo Sapiens propagation at the current rate presents seemingly unsolvable problems, our Earth being ravished in so many ways with little or no foresight in the past or present. We cannot, or maybe should say may not survive. Many species in the animal kingdom, for different reasons, unable to cope with situations or kill-offs, catastrophes, changing climate, overpopulation, etc. have come and gone. Are we next on the list of extinction?.... But the grasses and weeds! Ah, the grasses and the weeds!

And the bugs! And the Bugs! With their tenacity for life, may go on and on till the death itself of our beautiful planet.

But the grasses and the weeds and the insects and the bugs and the bees will survive when long past we have fallen by the wayside.[35]

Haffer pushed the boundaries of the photogram. She expanded the visual possibilities, as she also had done in the 1920s and 1930s when she found the traditional medium of photography too limiting, by inventing a new technique to create three-dimensional images. This technique took the photogram from the two-dimensional x-ray type image to the realistic or narrative, with depth of foreground and background. In *California Horizon,* for example, the depth is accomplished by using sheets of glass, a series of exposures, and removing objects after different exposure times, thus giving it a three-dimensional appearance. The possibilities of this experimental technique were limitless, both for Haffer and for other artists.

Education, the "great social equalizer and means to self-realization" was part of her life's journey. She began the decade of the 1960s by attending the Institute Allende, an art school in San Miguel de Allende, Guanajuato, Mexico. By then she had her trailer anchored in Harbor City (Los Angeles), California, for her regular sojourns south in the winters. In 1967 she attended a seminar at Santa Cruz University conducted by Ansel Adams (1902–1984). In attendance were Beaumont Newhall, noted art historian and photographer, and his wife, art critic Nancy Newhall.

Throughout the decade of the 1960s and into the 1970s, Haffer did many photographic series as Sunday inserts for Tacoma's *News Tribune and Sunday Ledger.* The photographic essay series published in the Sunday magazines were to be the basis for a chapter book of her photographs that was scheduled to be published. However, she would pass away before it could be done. Virna May Haffer passed away in her sleep on April 5, 1974 of coronary artery disease.

FIGURE 2.34.
VIRNA HAFFER,
Self Portrait, circa 1960s.
Photogram, 13 ½ x
10 ½ inches. Collection
of the Washington State
Historical Society, gift of
the estate of Virna Haffer,
1974.35.12.57.

THE END

To encapsulate Haffer's sixty-year career is difficult. I'm inclined to agree with the unnamed writer who reviewed her Winthrop Hotel Exhibition of 1933: "Her work is much too varied in subject matter and treatment.... It is impossible for one to neatly tag her creations or recapture their strength in cold type."

What is consistent throughout her career, however, is her "zest for ferreting out the essence of life that moved about her."[36] Those who knew her best, her family, credit her upbringing in Home Colony, the utopian settlement on Puget Sound, as the most important influence. Its atmosphere of intellectual stimulation and focus on the freedom to make oneself as an individual helped her become a free spirit with an unbridled imagination. (fig. 2.34) She demonstrated throughout her life that she was willing to take on a challenge regardless of the consequences.

The following is a portion of the obituary of Fannie Rogers, Virna Haffer's mother, who passed way in Home suddenly on March 10, 1955.[37] It seems fitting to use it to describe her daughter.

> *She continued to exemplify all the finest qualities of individualism, initiative, independence and never ending concern for her fellow man, and to the end retained a vital interest in politics and social welfare. She was and will continue to be an inspiration to all who knew her, and will be greatly missed.*[38]

Virna Haffer was able to lead the viewer into a world that was uniquely her own making and create the striking photographs and photograms that appear here.

1 Virna Haffer, introduction to "Pictorial People," in "Sixteen Chapters in Photography" (unpublished manuscript, Tacoma Public Library Special Collections, Tacoma, WA, 1971).

2 "Haffer's Work Reveals Artist's Hidden World," *Tacoma* (WA) *News Tribune,* October 18, 1987.

3 David F. Martin, *Pioneer Women Photographers* (Seattle: Frye Art Museum, 2002); Naomi Rosenblum, *A History of Women Photographers* (Paris: Abbeville Press Publishers, 1994); Martin W. Sandler, *Against the Odds: Women Pioneers in the First Hundred Years of Photography* (New York: Rizzoli International, Inc., 2002).

4 Jack Ryan, "Once Called Land of 'Anarchy, Sin,' Home Notes Birthday Quietly," *Tacoma* (WA) *News Tribune and Sunday Ledger,* October 2, 1966, sec. A.; Jason Wehling, "Anarchy in Interpretation: The Life of Emma Goldman," March 15, 1994, http://www.spunk.org/texts/people/goldman/sp001520/emmabio.html (accessed 2007); Individualist anarchism supported the principles of individual rights free from government and passive resistance rather than violence as a weapon. They were distinguished from their anarcho-communist relatives, who used violence and agitation in an effort to destroy any form of government, rejected capitalism, and supported collective living environments rather than private property rights.

5 Gene and Lillian Randall, interview by Christina Henderson and David Martin, June 15, 2007.

6 Grace Pulliam, "A Southern Family in a Queer Place," *Nashville* (TN) *Banner,* Saturday Evening, November 28, 1914. This article is part of a collection of newspaper articles called "Home: There's No Place like Home: A Collection of Newspaper Articles about Home, Pierce County Washington," 1968, in the collection of Tacoma Public Library, NWR 979.7, H752H.

7 Lois Waisbrooker, "Restlessness," *Demonstrator* (Home Colony, WA), August 25, 1903, no sec.

8 Charles Pierce LeWarne, *Utopias on Puget Sound 1885–1915* (Seattle: University of Washington Press, 1995), 201.

9 Charles Pierce LeWarne, "The Children of Home," (unpublished, copyrighted paper, n.d.).

In an article on child freedom published in the *Agitator* in March of 1911, Henry Hanson expressed his dissatisfaction with conventional parenting and its "do-as-I-say-not-as-I-do" hypocrisy. Children were to be respected and included in adult activities. Their discrepancies in knowledge were due to inexperience, according to Hanson, and if they were included in activities, he felt that children's decision-making skills would increase greatly.

10 Paul Avrich, *Anarchist Voices: An Oral History of Anarchism in America* (Princeton: Princeton University Press, 1995), 333. Interview with Rebecca August, June 20, 1974. Rebecca was a former resident of Home Colony.

Haffer was witness to many defenses of personal freedoms. In 1911 four Home residents were arrested, found guilty, and jailed for swimming in the nude. Jay Fox, veteran of the Haymarket riots, active member of the Industrial Workers of the World, and resident editor of Home's last newspaper, the *Agitator,* published an editorial espousing his opinion on the matter. The editorial, titled "The Nude and the Prudes," led to his arrest for "publishing matter tending to encourage disrespect for the law and the courts." The Free Speech

League, the predecessor to the American Civil Liberties Union, involved themselves in the Fox case by staging a number of fundraisers (dances and concerts) throughout the country, with all proceeds donated to his defense fund. The lower court system ruled an appeal to the United States Supreme Court, and despite the immense support he had received from the Free Speech League, Fox eventually lost the case. He served six weeks of his jail sentence before he was pardoned by the governor of Washington State. Some speculate that the emotional cost of the months of activity surrounding the arrest and trial may have been a precursor to what was to be a growing disharmony between some colony members, which would eventually lead to the end of Home.

Home had factions within the colony population who fought over private property rights in both the superior and the state supreme courts, and in July of 1919, the colony was dissolved by superior court decree. It went the way of many of its utopian predecessors. Many of Home's families, including Haffer's mother, Fannie, with her new husband Webster Rogers and father Henry Hanson, continued to live their independent lifestyle on Joe's Bay until the end of their lives. Henry Hanson is buried in the cemetery at Home. According to historian Charles LeWarne, Hanson's is the only headstone standing in the Home Colony cemetery. An examination of cemetery records at the Key Peninsula Historical Society identified only one headstone left standing in Home cemetery—that of H. C. Hanson. Home Cemetery is located on land entrusted to the village of Home but is accessible only through private property. The Washington State Death Index for 1940–1996 lists the date of death for Henry C. Hanson as April 29, 1947.

11 *Children of Home: Stories from Home Colony*, compact disc, Key Peninsula Historical Society, 2005.

12 Randall interview.

13 Virna Haffer, introduction to "Pictorial People."

14 Randall interview.

15 Marriage certificate for Virna M. Hanson and Clarence E. Schultz, license # 26201, Pierce County, Washington, April 17, 1919. A. J. Schultz, Clarence's father, was an early Home Colony inhabitant; Clarence lived in Lakebay.

16 "Doesn't Bother Haffer," *Tacoma* (WA) *Tribune*, May 4, 1916. Paul Haffer would later become columnist "Septimus" for the *Tacoma Labor Advocate*.

17 On February 18, 1916, the *Tacoma Tribune* newspaper published a letter titled "A Lifter of Halos" in the "Daily Letter Box" section. In the letter, the author, Paul Haffer, in an effort to "persuade a few to gaze upon the actors in their true light" and remove the "halo from his head," asserted that George Washington was an exploiter of white and black slaves, a blasphemer, user of profanity, and "an inveterate drinker." Paul Haffer, who was defended by the "Haffer Defense League" organized by local socialists, was sentenced to four months in Pierce County Jail. He appealed on the grounds that the First Amendment entitled him to write what he wished but lost because he could not find the sources at the Tacoma Public Library to support his claims. He eventually served his four-month sentence in Pierce County Jail. It was a case that gained national attention in newspapers across the country, from the *Washington Post* to the *New York Times*. In addition, because Paul Haffer failed to register for the draft, he was also placed in service in the 12th Infantry Regiment. After fifteen months of service, he was given an honorable discharge and was quoted as saying, "service in the army has broadened me." He was proud of his service and received glowing reports by his superior officers. "Haffer Back with Altered Draft Views," *Seattle* (WA) *Times*, January 10, 1919.

18 Evadna Cooke, letter to Charles LeWarne, July 30, 1974.

19 "Photo Society to Show Haffer Salon Winners," *Tacoma* (WA) *News Tribune and Sunday Ledger*, June 3, 1966.

20 "Honorable Mention Awarded Tacoman in Picture Exhibit," *The Tacoma* (WA) *News Tribune and Ledger*, 1924; Haffer's fourth-place award was received at the "fifth annual" exhibition; The Frederick & Nelson salon began in 1919; David F. Martin, "Photographs by the Seattle Camera Club," *Art in America* 12, no. 1 (2000): 165.

21 "Tacoma Artist Has Pictures Accepted," *Tacoma* (WA) *Times*, May 10, 1930; Louise Hunt, "Block Prints of Tacoman Exhibited," *Tacoma* (WA) *Daily Ledger*, October 17, 1930, sec. A.

22 "Art exhibit at the Winthrop," *Tacoma* (WA) *Daily Ledger*, October 17, 1930.

23 "Art exhibit at the Winthrop," *Tacoma* (WA) *Daily Ledger*, October 9, 1933.

24 Salons were sponsored by camera clubs and adhered to strict established guidelines. If not followed, the photographer's work would not be acknowledged in the important annual trade publication *The American Annual of Photography* (1908–1953), a publication out of New York that appealed to readers practicing "classical" pictorial photography. Only about 10 percent of the work submitted was accepted and exhibited. It was therefore the test of the quality of a print and the goal of most pictorial photographers to have it accepted to the best photography salons. Several periodicals included photographs of the current salon winners—a badge of honor for the photographer. The national photography periodicals and the camera club magazines and bulletins were also an important source of information and news about trends in photography and state-of-the-art techniques. Christian Peterson, *After the Photo-Secession: American Pictorial Photography, 1910-1955* (New York & London: W. W. Norton & Company, 1997), 131.

Haffer's achievements in the 1930s included the publication of her pictorial photography in important photography journals on fifteen known occasions. Haffer was listed in the journal *The American Annual of Photography* under the prestigious list *Who's Who in Pictorial Photography* in 1927–28, 1929–30, 1930–31, and 1932–33. She had her photographs published in *The American Annual of Photography* in 1930, 1931 and 1933: *Robert* and *Isabel Keith Morrison*, 1930; *Dancing Teacher*, 1931; *Onya Latoor*, a bas-relief, 1933 (a bas-relief photograph is a 3D image created by superimposing a negative and positive image slightly off register). She shared the pages with luminaries in her field, such as William Mortensen, Imogen Cunningham, and Clara Estelle Sipprell. Examples of her pictorial photography were published in other important photography journals. She had three of her photographs published in the photography periodical *American Photography*: *Mother and Child*, in May 1933, a portrait which conveys a spiritual quality in the love of mother for child, with manipulations done to the negative; *Three Towers*, in September 1931, awarded fifth prize in their annual competition—a striking composition out of a purely utilitarian object; and *Cornelius Vanderbilt*, in January 1935, a portrait with caricature-like qualities, which was awarded Honorable Mention in *American Photography's* annual competition. Haffer's work was also published in *Camera Craft*, the club journal of the California Camera Club, which was the largest camera club in America at that time. *Camera Craft* published monthly out of San Francisco until 1942 and embraced both pictorialism and commercial photography. Haffer had three photographs published in *Camera Craft* in 1934: *Three Towers* was awarded fifth place in the advanced category out of thirty entrants, including Max Thorek; *A Skier of Mt. Rainier* was awarded fourth place in May; and in September, *Cornelius Vanderbilt*, an unusual bromide print, received

a fifth place award. In 1936, for her print *Hardrock Randall*, Haffer was awarded the First Advanced Medal by *Camera Craft*. The print was artistically daring, with a cropped image and a "modernist attitude." In 1938, she received a fifth place award for *Franz Brasz, Artist*, an innovative use of two negatives. *Rolf*, published in May 1939, used severe cropping again to accentuate the profile in such a way that it was described as "radical enough to appear definitely objectionable to the conservative minded." *Photo Art*, a photography magazine that has been difficult to find information on, published two photographs by Virna Haffer from the advanced class of photographers: *Laurie*, a portrait of a young girl, in August 1938, and *Jim*, produced with a "currycomb" cross-hatch design in February 1939.

In 1937, the *First Annual National Photographic Salon for Women* was held in Philadelphia. It was primarily a pictorial photography exhibition. Haffer submitted landscapes, a popular pictorial theme. Haffer's submissions were noted in art photography historian Naomi Rosenblum's publication *A History of Women Photographers* on page 156—an important notation in an international publication.

25 "Tacoma Artist Has Pictures Accepted," *Tacoma* (WA) *Times*, May 10, 1930.

26 "Virna Haffer Exhibition Is Exceptional," *Tacoma* (WA) *Daily Ledger*, October 9, 1933.

27 Virna Haffer's second husband, Paul, was involved in a labor activist group called the Unemployed Citizens League, an organization founded in Seattle in 1931 to help the unemployed find work. Virna Haffer photographed workers in various occupations. She also captured on film a 1927 Seattle demonstration in protest of the guilty verdict of Sacco and Vanzetti, the two anarchists who were executed after having been found guilty of bank robbery in Massachusetts. Both the cities of Seattle and Tacoma had their "Hoovervilles" established in 1931 during the Depression. Seattle's Hooverville was located on land owned by the Port of Seattle south of Pioneer Square. Tacoma had its shanty town called "Hollywood-on-the-Tideflats." It is believed that Virna Haffer photographed both.

28 A. D. Coleman, *The Grotesque in Photography* (New York: Summit Books, 1977), 148.

29 Frank Fraprie, ed., "Cornelius Vanderbilt," in *American Photography*, vol. 29, no. 1 (Boston: American Photographic Publishing Company, 1935), n.p.

30 "Virna Haffer Photographs Are Exhibited," *Tacoma* (WA) *News Tribune and Sunday Ledger*, September 15, 1960; "Virna Haffer Photos Now on Exhibit," *Tacoma* (WA) *News Tribune and Sunday Ledger,* November 6, 1960; "Photo Society to Show Haffer Salon Winners," *Tacoma* (WA) *News Tribune and Sunday Ledger*, June 3, 1962; Tacoma Artists File—Haffer, Tacoma Public Library Special Collections, Tacoma, WA.

In the 1950s Haffer received numerous awards for her photographs and continued participating in exhibition activities at a fervent pace. A partial list is included in the following paragraphs. One source estimates Haffer had 320 acceptances from sixty-four negatives to salons the world over by the early 1960s. More achievements are likely to come to light as more research is done on her achievements.

In the spring of 1951, Haffer was back at the Winthrop Hotel for a solo exhibition titled *Continental Art*, sponsored by Professional Photographers Association of Pierce County. Photographs from her European vacation from the summer of 1950 were included.

In 1953, 1954, and 1955 Haffer won "Print of the Year" citations from the Evergreen Camera Club of Seattle for the photographs *Homespun Harmony*, *Hodet*, and *Laurie* respectively. Because she had won so many of their honors, Haffer received permanent possession of the award and was eliminated from further competition. *Hodet* was

published in the June-July issue of *Photo Northwest*. *House in Cornwall*, taken on her European vacation in 1950, was accepted in 1952 at the *Rochester International Salon of Photography*. *Foundry at Treadwell*, *Waif* (1955), *Only Two!!* (1955), *Spider* (1955), *Furnace Creek Tunnel* (1956), *Kumquats and Unbaked Pottery* (1956), *Beauty and the Beast* (1956), *Crossroads in Culture* (1956), *Sundown in Sand Dunes* (1956), *Lake Atitlan* (1958), *Straight and Narrow* (1958), *Tonala Pottery* (1958), *Maestro* (1958), *On the Steps of Santo Tomas* (1959), and *Autumn Lanterns* (1959) were accepted to multiple salons throughout the fifties. In 1955 two Haffer photographs, *Old Tacoma Hotel Fire* and *Bridge Cable* (taken in San Francisco), were published in the magazine *Popular Photography*. Seattle Photographic Society sponsored the *Seattle International Exhibition of Photography* in 1956 and showed her print *Old Tacoma Hotel Fire*. In 1959 she was part of the jury for this same exhibition.

Haffer was an active member of many photography organizations and educational groups in the 1950s. She was a member of the Professional Photographers Association of Pierce County, Out-of-Town Photographers, Tacoma Photographic Society, Photographic Society of America, Evergreen Camera Club of Seattle, and Camera Club of Palm Springs.

All of these awards and activities along with recognition for her early photograms (early 1960s) and her solo exhibition at the Massachusetts Institute of Technology in October of 1960 would earn her the "points" she would need to earn one of the highest honors in professional photography—a master's degree, awarded by the Professional Photographers of America in 1964.

"Tacoma Photographer Wins Master's Degree," *Tacoma* (WA) *News Tribune and Sunday Ledger*, August 12, 1964; Virna Haffer, scrapbook, Haffer Estate, Martin-Zambito Fine Art, Seattle, WA; A point system determined who received the distinguished master's degree from the Professional Photographers of America (PP of A). Merit points were earned by having work exhibited by the national organization, giving lectures, presenting demonstrations in national and state photographic groups, and participating in other organizational programs.

31 According to the catalogue for the *18th Annual Victoria International Salon of Photography* of October 1961, Haffer's photogram *Aftermath* was accepted to the Victoria, Canada Camera Club salon exhibition. *Clockworks*, an abstract, was listed in the catalogue for the New York Camera Club and the Photographic Society of America's International Photographic salon and exhibition for 1961. At the time of the publication of this essay, these are the earliest sources that document the first exhibition of any of Haffer's photograms. Haffer was honored in 1962 in the Annual Exposition of Professional Photography in Chicago for the photograms *Aftermath* and *California Horizon* and again in 1964 for four photograms: *Tomorrow World*, *The Essence*, *Unknown*, and *Then the Rains Came*. All of the early national successes suggest a deep involvement with the photogram technique in the decade of the 1950s.

32 Interestingly, famous Hungarian-born photogram artist, painter, and art theorist Gyorgy Kepes (1906–2001) was a professor of architecture at M.I.T. during the time of her exhibition.

33 Virna Haffer, *Making Photograms: The Creative Process of Painting with Light* (New York: Hastings House Publishers & Amphoto, 1969), 11.

34 Ibid.

35 Virna Haffer, introduction to "Pictorial People."

36 "Virna Haffer Exhibition Is Exceptional."

37 Charles Pierce LeWarne, *Utopias on Puget Sound*, 171.

Upon arriving in Home Colony, it was expected that everyone would build their own homes, provide their own employment, and adhere to the only stated purpose in the official charter: "[to aid in] establishing better social and moral conditions." In need of a residence, the Hanson Family cleared their own parcel of land and used the lumber to build a house, which Fannie Hanson Rogers would describe years later as a "shack built of logs and shakes, with rough boards for side walls and a small stovepipe chimney with a bucket on hand in case of fires." At age sixty, after raising her two daughters in this "shack," she decided she wanted to build her dream house. Fannie roughed out house plans and cleared the land, carefully selecting cobblestones for the foundation of the house. Then she took an ax and hammer and destroyed the shack—a symbol of hardship and inconvenience. For two years she cooked in her "roothouse" and slept in a tent as she labored away cementing the foundation and framing the house. When able, she moved into the partially finished home to finish the remainder, which took an additional three years. Five years and "almost insurmountable obstacles" did not stop the tenacious and unshakable Fannie Rogers from successfully completing her dream home. It is easy to see where Virna Haffer got her fearlessness when faced with a challenge and versatility of intellect to see the many complexities of a problem brought to resolution. "This Is the Cottage That 'Jill' Built," *Tacoma* (WA) *Sunday Ledger*, April 6, 1930.

38 Virna Haffer, scrapbook.

GALLERY TWO

SELECTED WORKS

Top:
VIRNA HAFFER, *Jaw of a Mouse*, circa 1965. Gelatin silver print, 7 1/4 x 9 1/8 inches. Collection of the Washington State Historical Society, gift of the estate of Virna Haffer, 1974.35.12.15.

Bottom:
VIRNA HAFFER, Untitled, (Newell Griffith), circa 1935. Gelatin silver print, 7 15/16 x 9 7/8 inches. Collection of the Tacoma Public Library.

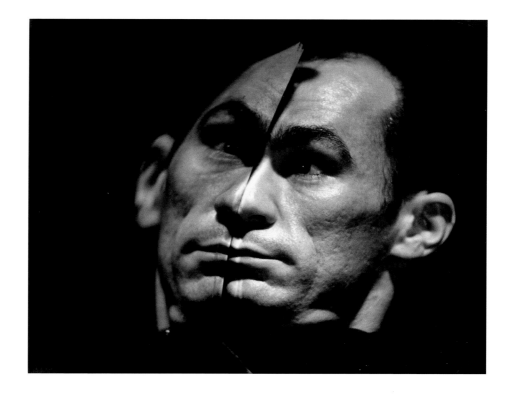

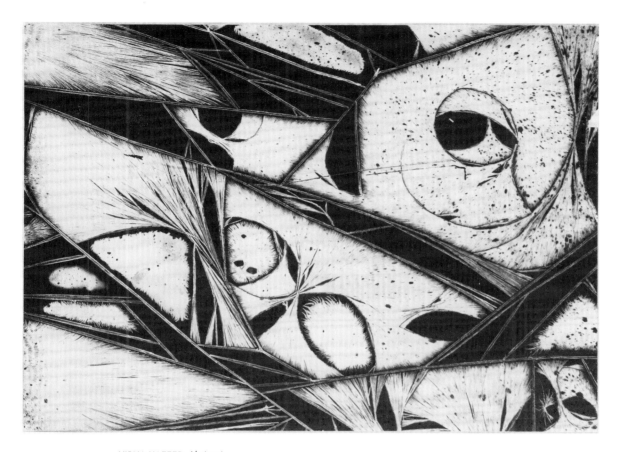

VIRNA HAFFER, *Abstract #2*, circa 1965. Photogram, 8 ⅝ x 11 ⅝ inches. Collection of the Washington State Historical Society, gift of the estate of Virna Haffer, 1974.35.12.52.

Haffer created a series of images by spraying various chemical substances on glass and when dried, magnifying the image in the photo enlarger. In this instance, she sprayed canned Christmas glitter onto glass and allowed it to crystallize.

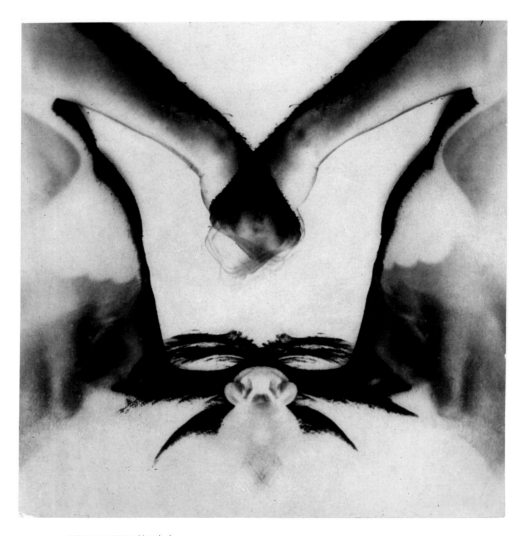

VIRNA HAFFER, Untitled,
circa 1934, printed later.
Gelatin silver print, 8 ½ x 8
inches. The Randall Family
Collection.

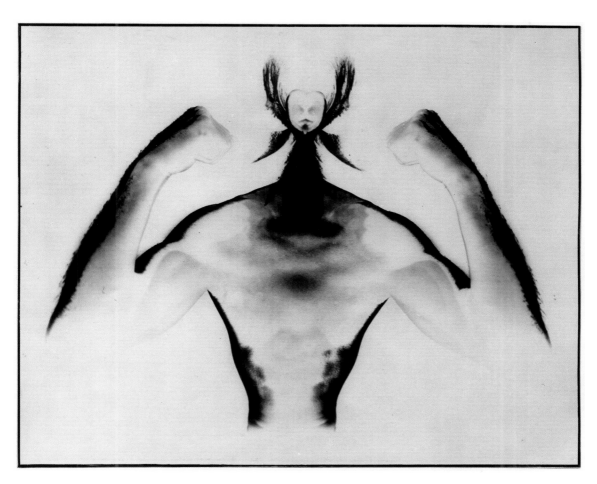

VIRNA HAFFER, Untitled,
circa 1934, printed 1938.
Gelatin silver print, 7 ¾ x
9 ½ inches. The Randall
Family Collection.

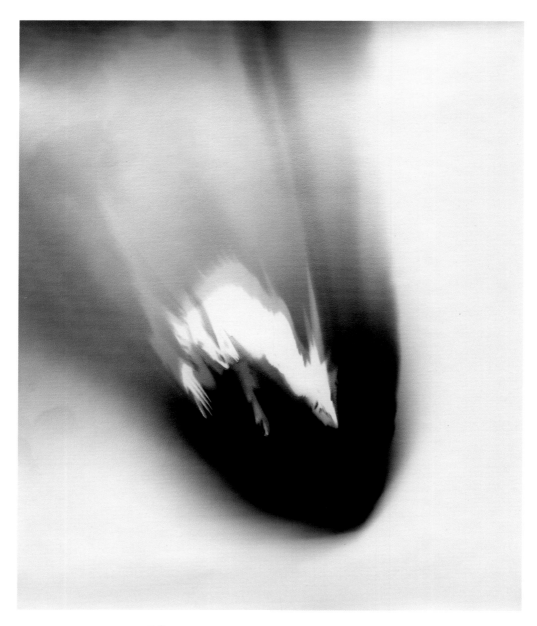

VIRNA HAFFER, *Falling
Shrew* (also titled *Down,
Down, Down*), circa 1965.
Photogram, 7 $^{13}/_{16}$ x
5 $^{3}/_{4}$ inches. Collection
of the Washington State
Historical Society, gift of
the estate of Virna Haffer,
1974.35.11.25.

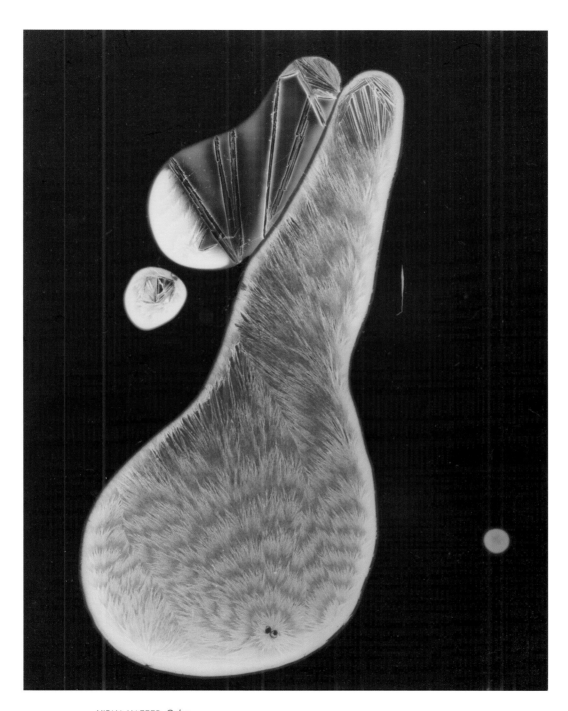

VIRNA HAFFER, *Color Abstract #1*, circa 1965. Color photogram, 13 x 10 inches. Collection of the Washington State Historical Society, gift of the estate of Virna Haffer, 1974.35.12.55.

Top:
VIRNA HAFFER, *Three Towers*, circa 1929. Bromoil print, 6 ¾ x 9 ½ inches. The Randall Family Collection.

Bottom:
VIRNA HAFFER, *Onya Latoor*, 1933. Bas relief print (solarized), 9 ⅝ x 7 ½ inches. Collection of the Washington State Historical Society, gift of the estate of Virna Haffer, 1974.35.12.43.

VIRNA HAFFER,
Orchelimum Vulgare
(Katydid), circa 1930.
Gelatin silver print with
texture screen, 9 1/4 x
7 3/8 inches. Collection
of the Washington State
Historical Society, gift of
the estate of Virna Haffer,
1974.35.12.31.

Left:
VIRNA HAFFER, Untitled, 1935. Oil on canvas, 64 x 19 inches. The Randall Family Collection.

Right:
VIRNA HAFFER, Untitled, 1940. Oil on canvas, 65 x 18 inches. The Randall Family Collection.

VIRNA HAFFER, *Seed*, 1935. Oil on canvas, 84 x 60 inches. Collection of Norman and Susan Randall. Photo by Ken Wagner.

VIRNA HAFFER, Cups with male figural handles, 1935. Ceramic, 4 ¼ x 4 ½ x 3 ¼ inches. The Randall Family Collection.

VIRNA HAFFER, *Eleventh Street Bridge*, circa 1929. Block print, 4 ½ x 6 ⅝ inches. Tacoma Art Museum, Gift of Carolyn Schneider, 1975.17.

VIRNA HAFFER, *Saturday Night*, circa 1929. Block print, 5 ½ x 5 ⅜ inches. The Randall Family Collection.

VIRNA HAFFER, *The Big House*, circa 1929. Block print, 6 ¾ x 4 ⅜ inches. Tacoma Art Museum, Gift of Carolyn Schneider, 1975.16.

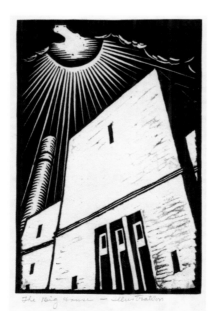

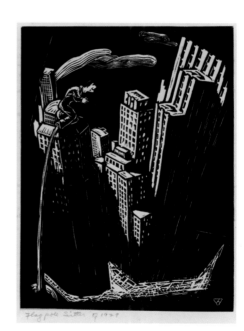

VIRNA HAFFER, *Flag Pole Sitters of 1929*, 1929. Block print, 8 x 5 ⅝ inches. The Randall Family Collection.

DAUGHTER OF DESTINY
VIRNA HAFFER AND THE TRANSCENDING OF REGIONALISM

David F. Martin

Early Work and Influences

Virna Haffer, who would become Tacoma's most noted and innovative photographer, was born in 1899. That very year, the Tacoma Camera Club was established as the first professional organization for the promotion and production of artistic photography in the city. Tacoma's Washington Camera Club soon followed.[1] Known as the "City of Destiny," Tacoma was making its initial cultural efforts to live up to the optimistic promise of the moniker.

Tacoma's Washington Camera Club was organized by curator and painter William H. Gilstrap (1840–1914), who served as its first secretary. The club met in the original Ferry Museum until its move in 1911 to the Beaux-Arts classical building on Stadium Way that now houses the Washington State Historical Society Research Center. Like their counterparts in neighboring Seattle, Tacoma's early photographic clubs included professionals as well as amateur hobbyists, usually from prominent local families. (fig. 3.1) Among them was studio photographer Byron Harmon (1876–1942), who became widely known for his views of the Canadian Rockies after he moved to Banff, Alberta. Perhaps the most successful was Wayne Albee (1882–1937), who opened his first studio in Tacoma in 1902 after working in Harmon's studio and supply company. Albee won numerous awards, developing his reputation as an artistic portrait photographer and having his name appear in several national photographic publications in the early part of the twentieth century.[2]

Elsewhere in the Northwest, photographers formed the Photographers Association of the Pacific Northwest (PAPN) in an effort to expand their knowledge of technical advancements as well as promote the artistic expressions of their members' work. They held their first convention in 1900. This extremely successful organization began through the efforts of several Portland, Oregon, photographers, notably Charles Butterworth (1858–1936), a painter and pictorialist photographer who had relocated from Ohio to Oregon in 1898.[3] Albert L. Jackson (1856–1922), a noted Tacoma portrait photographer, was the first president for the Washington chapter.

VIRNA HAFFER,
Self Portrait, circa 1929.
Gelatin silver print, 3 x
2 ³/₁₆ inches. Collection
of the Washington State
Historical Society, gift of
the estate of Virna Haffer,
1974.35.11.7.64.1.

Born in Knoxville, Iowa, Jackson moved to Oregon at the age of six. He attended the University of Oregon in Eugene, where he began his career in photography, opening a studio there in 1876. He moved to Tacoma in 1885.[4] Edward S. Curtis (1868–1952), renowned for his Native American subject matter, served as vice president for the Washington chapter.

It was soon after this blossoming of interest in artistic photography that Virna May Hanson and her parents settled in the area. In 1907 they moved from Illinois to the utopian community Home Colony near Tacoma on Joe's Bay in Puget Sound. Her parents' choice to live in a progressive community like Home Colony is evidence of the liberal and independent environment in which they raised Virna and her younger sister Mildred. Home was referred to as an anarchist enclave; it attracted residents who were seeking an alternative to urban living and disdained physical violence and the social restrictions imposed by organized religion and authoritarian government. (fig. 3.2)

Virna's father, Henry C. Hanson, creatively stated his own personal credo on religion in a published, undated poem.

> *A Lady In Hell*
>
> *A lady friend of mine is now in hell,*
> *If what some preachers say and teach be true;*
> *She died as she had lived, an infidel;*
> *Her parents held belief should be tabu.*
>
> *They said that what one cannot demonstrate*
> *Should not be spoken of as being fact.*
> *As near the truth as anyone could state,*
> *It seemed to her—a rule on which to act.*
>
> *For just believing what her parents said,*
> *In hell she has been writhing forty years;*
> *Good Christians say that's where she made her bed—*
> *The thought, to them, does not bring any tears.*

But tho' she should remain a trillion years
In hell, her sentence even then would be
No nearer to the end. It thus appears
She never can atone, from hell be free.

If any judge, as punishment for crime
Should sentence anyone to roast a year
Within some fiery furnace, thus to mime
The Christian god, we'd put him in his bier.

One hour of hell, if such there were, would seem
An age. One year of such should expiate
A billion of the worst of sins, redeem
The world, and satisfy God's hellish hate.

If I believed there were such monstrous God,
I could not feel for him aught else than hate,
And think of him as but a pious fraud,
A hypocrite, the devil's running mate.[5]

FIGURE 3.2.
BURNZ AND CO., NEW
YORK, *The Liberal Hymn
Book,* copyright 1880.
The Randall Family
Collection.

The trajectory of Virna Haffer's life and artistic vision were inextricably tied to the open-minded environment in which she was raised. Haffer would become an innovator in the burgeoning field of art photography and a major contributor to Tacoma's cultural landscape.

As a young girl, Haffer was intrigued with a photographer that came to Home Colony to make group portraits of some of the residents. The experience made a lasting impression, and at the age of ten, she decided that photography would be an integral part of her life.[6] In an unpublished manuscript, her lifelong friend Elizabeth "Bettie" Sale described Haffer's early experiences with photography.

> *When she was fourteen years old Virna went to live in Tacoma, to work for her room and board with a family, as many young girls from the country and nearby small towns did in those days. She enrolled at Stadium High School, but soon learned that as a freshman, she could not be permitted to begin the studies she wished to pursue. At once she left school and went to work in the photographic studio of a then popular woman photographer. Of this experience, Virna said once, this woman taught her nothing at all about making pictures. But, keenly observant, she must have learned a lot and gone on to study more, for soon she taught herself to retouch negatives*

for other photographers by reading a book she borrowed from the public library.[7]

The female photographer that Sale referred to was Harriette H. Ihrig, whose studio opened around 1905 at 1107 South E. Street. Ihrig became known for her naturalistic children's portraiture even though her studio had quite an inauspicious past. "The studio where the greater portion of Tacoma mites 'have their pictures took' was once the official police Rogue's gallery, where the criminals of the city were photographed, numbered, measured and officially made one of the great army of enemies to the community."[8] Ihrig refurbished the Rogue's gallery with Mission-style furniture, and it became a popular studio for family-oriented portraiture. With customary youthful bravado, Haffer claimed not to have learned anything from Ihrig, although this is highly unlikely. What is certainly possible is that she read the numerous photographic publications available, such as *Camera Craft* and *Photo-Era*, while working in the Tacoma studio, keeping abreast of modern trends and significant artists in the field. Ihrig was very active professionally and served as vice president of the PAPN in 1912. In a 1915 advertisement for the Ihrig Studio, which had by then relocated to the top floor of the lavish Tacoma Hotel, the studio presented itself as a source for "Fine Portraits for Particular People." The featured photographer at Ihrig's was a woman named Georgene Bagger, who listed herself as an "artist," implying that her work was distinct and rose above pedestrian commercial portraiture. Ihrig relocated to Spokane in 1924 and continued a successful career in photography into the 1930s.[9]

By 1916 Haffer was living independently and advertising herself as a photographer in the local phone directory. During these early years, she most likely befriended Wayne Albee, the leading pictorialist and portrait photographer in the state at that time. His last Tacoma studio, Ye Likeness Shop, was located in the Chamber of Commerce building, but he soon moved to Seattle to join forces with Ella McBride (1862–1965), who opened her own studio that same year, after managing the studio of Edward S. Curtis since 1907.

Haffer's earliest extant photographic works have survived in albums that she carefully assembled over her lifetime. A lovely self-portrait dated 1916 attests to her early skill

in the medium. (fig. 3.3) Other works created in these beginning years include standard floral still-life compositions (fig. 3.4) and landscapes. An image of a swinging bridge in Walker, Oregon, with its dramatic foreshortening and emphasis on shadows, shows her initial interest in artistic composition and budding command of perspective. (fig. 3.5) This photograph would mark her earliest fascination with bridges, a subject she would come back to frequently over the following decades. Her study of trees and water in Tacoma's Wright Park show her awareness of a pictorialist style of perspective, with the elevated horizon line and elongated reflected foreground obviously influenced by Japanese prints. (see fig. 1.1, page 14) Pictorialism was the leading style of artistic photography at that time and was characterized by the use of various darkroom techniques that imparted an atmospheric and impressionistic effect to the subject.

FIGURE 3.4.
VIRNA HAFFER, Untitled, 1918. Gelatin silver print, 3 ⅛ x 4 ⅛ inches. Collection of the Washington State Historical Society, gift of the estate of Virna Haffer, 1974.35.11.8.24.1.

FIGURE 3.5.
VIRNA HAFFER, *Swinging Bridge in Walker, Oregon,* 1919. Gelatin silver print, 4 ½ x 3 ⅜ inches. Collection of the Washington State Historical Society, gift of the estate of Virna Haffer, 1974.35.11.8.49.2.

Most of the photographs that she produced over the next few years portray family members, travels, and various love interests. After her brief marriage to Clarence Shultz, which ended in 1920, she met Paul Haffer, whom she would marry the following year. An exciting and unique-looking man, he willingly posed for his young wife. Being a nontraditionalist himself, he indulged her artistic impulses by comically mugging for the camera in unusual clothing and sometimes posing in the

nude. Paul had connections to Home Colony as well, and his open-mindedness gave her room to expand her own career and independence as a studio photographer and artist.

Undoubtedly she attended local photography exhibitions whenever possible, especially the highly regarded Frederick & Nelson salons that began in 1920 in Seattle. Their successful first salon attracted luminaries from California such as Edward Weston (1886–1958), Margrethe Mather (1886–1952), Louis Fleckenstein (1866–1943), and John Paul Edwards (1884–1968), all of whom won prizes in the salon.[10] Haffer may have become acquainted with the work of these photographers while living in California during her brief marriage to Shultz.

In 1923 Paul and Virna had a son whom they named Jean Paul. Like most parents, the Haffers wanted to capture their child's physical development, so Virna began taking photographs of her infant son, initially just to record his physical appearance but then using the child as a model for experimental works. Virna carefully recorded facts about Jean Paul such as his height, weight, and growth over the months and even tenderly recorded his first laugh on June 25, 1923.

FIGURE 3.6.
VIRNA HAFFER,
Fraidy Cat, circa 1923.
Gelatin silver print,
11 x 6 ½ inches. Collection
of the Washington State
Historical Society, gift of
the estate of Virna Haffer,
1974.35.12.23.

It is likely that Haffer continued to attend the Frederick & Nelson salons in Seattle, as they had quickly attracted a great deal of national publicity and success. In their fifth annual of 1924, six of her works were accepted. Wayne Albee was one of the three judges for the competition and served as chairman. Most of Haffer's works depicted small children in various poses. One work, titled *Fraidy Cat*, won a five-dollar prize that was announced in the national publication *Photo-Era*. This work depicts a nude study of a young girl posed in a vulnerable position and crying. (fig. 3.6) Another work from this period depicts a nude male child

FIGURE 3.7.
VIRNA HAFFER,
Me An' My Shadow, circa
1923. Gelatin silver print,
9 ½ x 7 ½ inches. Collection
of the Washington State
Historical Society, gift of
the estate of Virna Haffer,
1974.35.12.18.

blowing up a balloon and casting a wide background shadow to make an interesting and dramatic design. (fig. 3.7) These artistic images of nude children were not uncommon—Edward Weston produced a noted series of nude studies of his prepubescent son Neil around this time. These photographs expressed an innocence and sense of discovery in much the same way that paintings had done in previous centuries.

One of Haffer's photographs in the 1924 salon was a work titled *His First Growth* (fig. 3.8), which appears startlingly modern for its time. The photograph is a blunt depiction of the back of her infant son's head, foregoing his facial features in favor of emphasizing the abstract shape of his sparsely covered skull. To be included in an

FIGURE 3.8.
VIRNA HAFFER, *His First
Growth*, 1923. Gelatin silver
print, 9 ⅜ x 7 ⅜ inches. The
Randall Family Collection.

To create this print, Virna Haffer photographed her infant son Jean's head using natural light from an open window. During printing she reversed the negative and paper and printed it through the back of the paper.

exhibition of this stature was a great achievement for the young woman, whose work was now hung with several nationally recognized photographers. Besides the national and international artists who were included in the show, many of the key members of the recently formed Seattle Camera Club (SCC) were featured. This exhibition also marked the debut of SCC member Yukio Morinaga (1888–1968), who would have such a significant influence on Haffer's life as an artist.

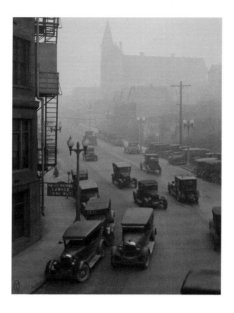

Haffer's budding reputation as an artistic photographer of children soon caught the attention of her friends and neighbors, who enlisted her services to photograph their children in unorthodox poses. Thus began the start of her successful portrait studio, which she maintained for nearly fifty years.

When the SCC formed in 1924, many of Seattle's most prominent Issei (first-generation immigrants from Japan) photographers became members, including founding member Yukio Morinaga. (figs. 3.9 and 3.10) Organized by the highly acclaimed Dr. Kyo Koike (1878–1947), the group held its first exhibition in 1925 just as the Frederick & Nelson salon concluded its final exhibition. The successful activities of the SCC members were recorded in a bilingual publication called *Notan*, which also included translations from Japanese literature.

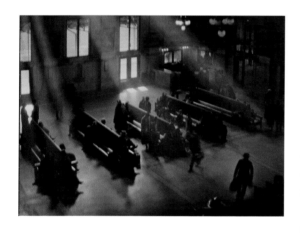

Buoyed by the SCC's success, Tacoma photographers soon followed suit by forming a second incarnation of the Tacoma Camera Club (TCC) in 1926. Dr. Koike gave a small notice of the TCC in the April 8, 1927, issue of *Notan*.

We accepted with pleasure the invitation by Mr. W. M. Eshelman, President of the Tacoma Camera Club. Dr. Koike and Mr. F. A. Kunishige attended the monthly meeting, which was held at the Tacoma Chamber of Commerce on the night of March 18th and showed a few prints by our club members. The Tacoma Camera Club is only five months old and has fifteen members at present. We heartily welcome the new organization and wish it may make a name in the pictorial photographic field very soon.

Haffer's first recorded attendance at an SCC meeting was noted in the November 9, 1928, issue of *Notan*. The editor, Dr. Koike, stated:

Our forty-fourth monthly meeting was held at Gyokkoken Café in Seattle's Nihonmachi [Japan town] on October 12th. Twelve members were present

and our guest was Mrs. Virna Haffer of Tacoma Camera Club, who came here to attend the meeting. She brought her eight prints of various subjects, to ask the opinion of some of our members about her pictures. We take off our hats to her earnestness and modesty.

She began to attend their regular meetings and officially became a member. Besides her photography, she also brought along some of her original block prints that she had recently begun making and offered them up for criticism by the mostly Issei members.

In the 1928 SCC exhibition, Haffer exhibited an unusual photograph titled *Gian Paolo* that had intense and disturbing qualities. (fig. 3.11) It must have appeared shocking in comparison to the entries by other SCC members, who preferred to stress beauty and poetic line as inspired by Japanese ukiyo-e prints of the eighteenth and nineteenth centuries. Haffer's work may have referenced *kaidan*, Japanese ghost story apparitions, which appear in the works of artists such as Utagawa Kuniyoshi (1797–1861).

This exhibition included two European photographers who appear to have influenced Haffer's development as an artist. The Dutch pictorialist Henri Berssenbrugge (1883–1959) exhibited five portraits, one of which was illustrated on the cover of the December 14, 1928, issue of *Notan*. (fig. 3.12) This portrait of the writer Edward B. Koster (1861–1937) displays several features

FIGURE 3.11.
VIRNA HAFFER,
Gian Paolo, circa 1929.
Gelatin silver print,
13 ⅛ x 10 ¼ inches.
Collection of the
Washington State Historical
Society, gift of the estate of
Virna Haffer, 1974.35.12.60.

FIGURE 3.12.
Cover of the Seattle
Camera Club's bulletin,
Notan, from the December
14, 1928 issue, depicting
a portrait by the Dutch
pictorialist Henri
Berssenbrugge. The
Randall Family Collection.

NOTAN

BULLETIN OF THE SEATTLE CAMERA CLUB

Affiliated with The Royal Photographic Society of Great Britain.
Member of Associated Camera Clubs of America

NO. 55 DECEMBER 14, 1928 Price Ten Cents

PORTRAIT by Mr. H. Berssenbrugge, The Hague, Holland
*Fourth Seattle International Exhibition
of Pictorial Photographs.*

Published Monthly on the Second Friday Subscription One Dollar a Year

THE SEATTLE CAMERA CLUB

422½ Main Street · · · Seattle, Washington

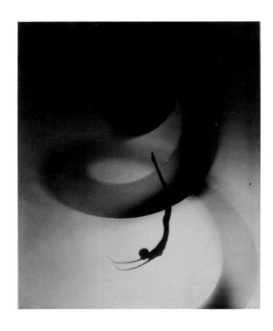

that Haffer would soon incorporate into her own work—the distortion of the subject, which is elongated and stretched (see fig. 1.11, page 19), and the unusual background treatment, resembling large, painted brush-strokes. Like Haffer, Berssenbrugge alternated between standard pictorialism and experimental work. He also produced photograms that sometimes used insects and wings incorporated into the designs, something Haffer would later do in the 1960s, though in a much more sophisticated manner.

The Czech photographer František Drtikol (1883–1961) was also included in this and other SCC exhibitions. His intense, innovative work undoubtedly captured Haffer's attention. Besides his geometrically designed and erotic female nudes, Drtikol also made images that are compatible with the photogram process used by Haffer in the later part of her career. Drtikol used paper cutouts to create ethe-real images of female spirit-like beings that are elongated and mysteriously bathed in bright light. They reflect his practice of Buddhism and other spiritual inclinations while adding a new depth to his imagery. (fig. 3.13) Haffer would also use torn paper to create imagery that mimicked landscape and figures in her photograms.

Dr. Koike reluctantly admired Drtikol's work and maintained a correspondence with him over the years. In the September 9, 1927, issue of *Notan*, Koike singled out a few of the exhibitors in the SCC's third annual exhibition. He noted, "Mr. Frank Dritikol [sic] of Czechoslovakia shows his peculiar method in the three nude studies. His handling of subjects is very unusual and strange, but he never goes wrong."

These early SCC exhibitions were regionally important, as they brought examples of international artistic photography, especially modernism, to Seattle before the estab-lishment of the major museums. This was especially useful for those local artists who were unable to travel to larger cities or worked in remote parts of the state. They were afforded the opportunity to view the works in person, rather than through reproductions in publications that were technologically unable to re-create the quali-ties that made such photographs accepted as works of art.

When the SCC disbanded in 1929, Haffer, like everyone else, was preoccupied with maintaining an income during the dismal economic depression that lay ahead. It is unfortunate that this situation started just as her artistic career began to blossom.

With her portrait studio established in Tacoma, and counting on the renewable stream of proud young parents who continued to have portraits made of their children in spite of the Depression, she and friend Yukio Morinaga began their lifelong collaboration. Haffer had previously done all of her own printing, but she eventually entrusted this to Morinaga, thus providing him with an income during these challenging years.

Besides being a photographer, Haffer also produced a significant body of work in the field of relief printmaking. Since she had no formal art education, it is unclear how she began producing prints. It is most likely that she learned the art of carving blocks through her close friendship with Waldo S. Chase (1895–1988) and W. Corwin Chase (1897–1988), two peripatetic brothers who produced some of the finest color woodcuts in the region beginning in 1926. Haffer's print production began around 1927, and it is one of the largest extant bodies of work in relief printmaking made by any Washington State artist of the period. Haffer would sometimes use her photographs as the basis for her prints, usually made from wood or linoleum blocks. (figs. 3.14, 3.15, 3.16, and 3.17) For the most part, she only exhibited her relief prints locally, with the exception of her 1929 membership with the renowned Philadelphia Print Club, in whose exhibitions she likely participated. The Northwest Printmakers Society (NWPS),

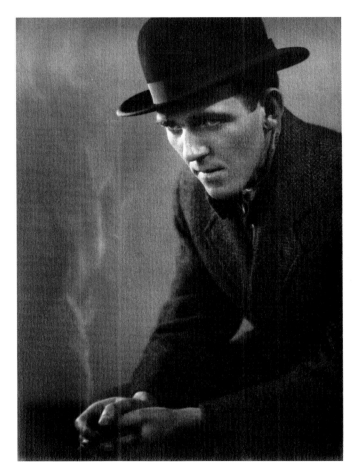

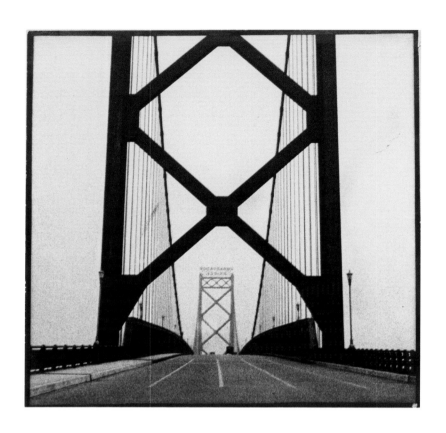

FIGURE 3.16.
VIRNA HAFFER,
The Bridge, circa 1930.
Gelatin silver print, 9 ½ x
9 ½ inches. Collection of the
Washington State Historical
Society, gift of the estate of
Virna Haffer, 1974.35.12.50.

FIGURE 3.17.
VIRNA HAFFER, *The Bridge*,
circa 1930. Block print,
7 ⅞ x 6 ⅜ inches. The
Randall Family Collection.

FIGURE 3.18.
VIRNA HAFFER,
Norah's Ark, circa 1930.
Block print, 4 ⅞ x 3 ⅞
inches. The Randall Family
Collection.

whose first exhibition
was also in 1929, became
a successful venue for
printmaking and attracted
national and international
artists. Haffer exhibited
her prints with the organi-
zation in 1932 and 1934.

Her young son Jean also
produced prints with the
help of his mother and
exhibited them with the
NWPS the same two years.
Jean, at the ages of five
and six, created prints
with exuberant titles such
as *The Animal That Scared
Betty* and *Angel Throwing
a Man Down To Hell.*
Jean's mispronunciation
of the biblical story of Noah's Ark inspired his mother to produce a whimsical block
print titled *Norah's Ark*. (figs. 3.18, 3.19, and 3.20)

FIGURE 3.19.
JEAN HAFFER (American,
born 1923), *Angel Throwing
a Man Down to Hell,* 1929.
Block print, 6 ½ x 4 ¾
inches. The Randall Family
Collection.

FIGURE 3.20.
JEAN HAFFER (American,
born 1923), *Untitled,* 1929.
Block print, 6 ½ x 4 ¾
inches. The Randall Family
Collection.

At the ages of five and six,
Haffer's son Jean produced
a series of precocious
block prints that were
displayed with his mother's
work in several exhibitions.
The print depicting the
screaming mother figure
was produced during the
period of his parents'
impending divorce.

Within the realm of pictorialism, the female nude was used widely in compositions, and Haffer's work included many such studies. Besides using her close friends as models, she also posed herself in nude figure studies throughout her career. (figs. 3.21 and 3.22) However, the use of the male nude is less common in this genre, especially by female photographers of that period.

In the late nineteenth and early twentieth centuries, a few painters, such as Thomas Eakins (1844–1916) and Maxfield Parrish (1870–1966), utilized nude photographic studies of their own bodies as models for their paintings. In Parrish's case, he adapted his physical attributes to pose for both male and female figures. However, in the 1920s, at the time that Haffer's work matured, the male nude was rarely exhibited in salons, especially if it had sensual or erotic undertones that belied the permissible classical inferences. There were a few exceptions though. Boston's Fred Holland Day

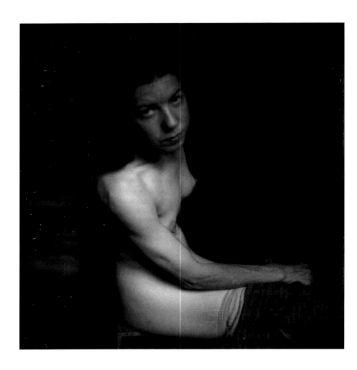

FIGURE 3.21.
VIRNA HAFFER,
Self Portrait, circa 1935.
Scanned from the original
negative. Collection of
the Washington State
Historical Society, gift of
the estate of Virna Haffer,
1974.35.10.1563.1.

FIGURE 3.22.
VIRNA HAFFER,
Betty Churchward, circa
1928. Scanned from the
original negative. Collection
of the Washington State
Historical Society, gift of
the estate of Virna Haffer,
1974.35.10.970.1.

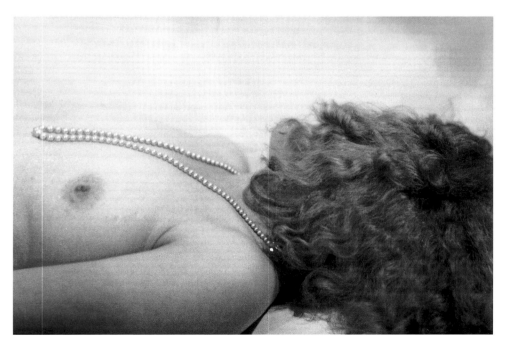

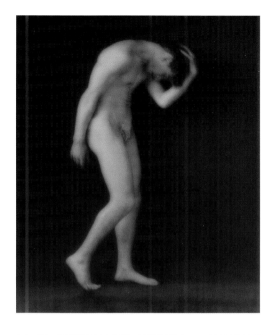

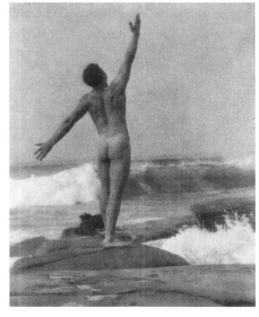

(1864–1933) was the most successful pictorialist whose male nudes formed a major part of his oeuvre in the first two decades of the century. The Czech pictorialist Rudolph Koppitz (1884–1936), who had also exhibited with the SCC, incorporated his own handsome physique into a number of his works, although he limited these studies to his own body. Locally, Imogen Cunningham had explored the subject in 1915 when she produced a group of nude studies of her husband, Roi Partridge, set against the backdrop of the foothills of Mt. Rainier. However, Cunningham's nudes were not well known or exhibited frequently until after the negatives were found and reprinted in the 1970s, when in hindsight the work seemed daring for the period.

Ancient Greek and Roman civilizations celebrated the idealized male form as a symbol of strength and independence within the structure of their militaristic cultures. However, during the Renaissance, the use of the nude figure, especially the male nude, sometimes reflected the obsession with shame and sexual repression associated with the growth of Christianity. SCC member Ella McBride was able to produce her male nude *Cain* within this context using a contemporary man, the model probably a young dance student from Seattle's Cornish School, posed in the biblical stance of expulsion and covered with a strategically placed fig leaf. (fig. 3.23)

Other local contemporaries, such as Wayne Albee, used the male form in a more classical and contemporary mode. His photograph titled *Son of Neptune* (fig. 3.24) depicts a man in an act of sheer jubilance, confronting nature in his prime. This

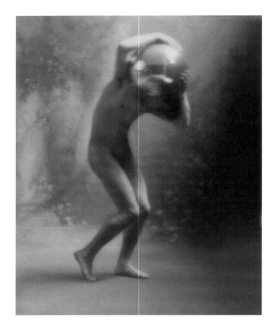

work, once owned by Haffer, utilized a pose reminiscent of dance icon Ted Shawn (1891–1972), who was photographed on several occasions by Albee. Frank Asakichi Kunishige (1878–1960) also used the male figure in several of his compositions though not nearly as often as the female subjects that he obviously preferred. The male subjects are often infused with a detached sensuality and rely less on erotic content. His untitled work of circa 1920 depicts a male figure, probably the same model that McBride used, but in this instance the figure is not allegorical. Kunishige appears to be representing some type of ethereal being against a dream-like garden backdrop, with a glowing aura of light suggesting a descending apparition. The figure's head is almost completely in shadow and is replaced by a mirrored sphere at the apex of the triangular composition. (fig. 3.25)

FIGURE 3.25.
FRANK ASAKICHI
KUNISHIGE (American,
born Japan, 1878-1960),
Untitled, circa 1920.
Gelatin silver print,
16 x 13 ⅛ inches.
Private Collection.

Haffer's exploration of the male nude was unique in early twentieth-century Northwest art and was outside the mainstream of her national counterparts as well. In Home Colony nudity was considered natural and did not carry the religious attachment of sin and puritanical repression that pervaded the social mores of the early twentieth century. As a result, her nude subjects are direct and sensual.

Haffer recruited her husband Paul to pose for her as well as other men, including fellow artists, like her friend photographer Paul Standar (1885–1966) (fig. 3.26), actor/director Craig Boardman, and her sister's truck-driver boyfriend, Nick. (fig. 3.27) A group of studies that she made in 1929 of artist W. Corwin Chase are highly unusual for the time within the regional and national context. Corwin and his brother Waldo Chase, both woodblock artists, appear to have spent time in Home Colony and were also raised in unorthodox households. Their grandparents, Noble and Olive "Mother" Ryther, were important Northwest social activists who established care facilities for orphans, unwed pregnant women, and prostitutes. The brothers lived in teepees that they designed themselves (some of the residents in Home Colony also lived in teepees), grew their own food, and maintained nontraditional lives.

In 1981 Corwin Chase published an unusually candid and somewhat bizarre autobiography in which he often refers to himself in the third person as "chief" or "Chenuis," the Chinook name for chief. In a chapter titled "Artist's Afternoon," Chase recalled the day that Haffer, accompanied by Bettie Sale, made nude studies

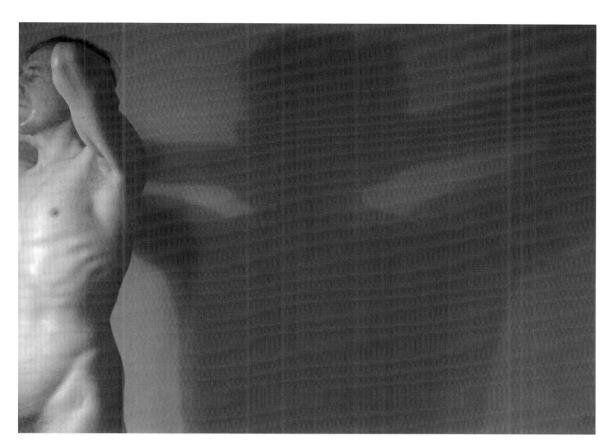

FIGURE 3.26.
VIRNA HAFFER,
Paul Standar, circa 1930.
Scanned from the original
negative. Collection of the
Washington State Historical
Society, gift of the estate of
Virna Haffer, 1974.35.10.1108.1.

of him at his secluded camp on Portage Point, off the Hood Canal. While printing up one of his color woodcuts, he was overcome by an impulse to shed his clothing and paint designs on his body.

> *I then removed that one and only garment, a silk scarf of bright colors, which was about my middle. Dipping the brush I began to paint a concentric design upon my left leg. I, Chenuis, continued absorbed in extending this (circle) design; my left leg-front was covered; I got out my mirror and placed it to get some idea of the effect.*

> *Of all the things that artists do—? But this body painting is not strange; an artist loves and worships beauty; and what is more beautiful than the body—the human body. But the Establishment can't take it. They get a sense of sin when they see bodies and see that love/lust is woven into it. Why?*

> *Because love/lust is the Enemy against which the Pure Believers have fought for 2000 defeated years. So perhaps Virna's personal vibrations had gone on ahead of her; and Chenuis' primordial impulses were astir—that some thrill might be more quickly stirred, in himself, or in a beholder if he were painted excitingly.*

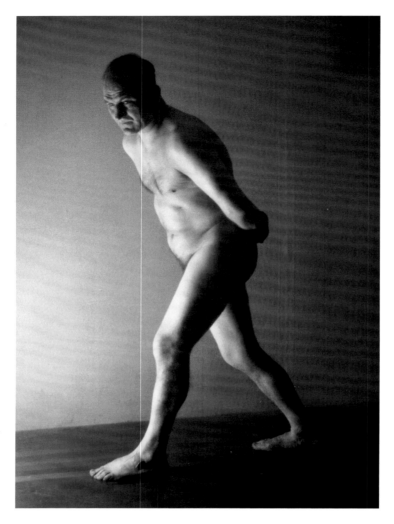

FIGURE 3.27.
VIRNA HAFFER, *Nick*,
circa 1938. Scanned from the
original negative. Collection
of the Washington State
Historical Society, gift of
the estate of Virna Haffer,
1974.35.10.1058.2.

The effect in the mirror seemed pleasing—? (What Was That Noise?) (Now would be the perfect time for callers to arrive!)

Someone was outside! Some person had brushed the side of the tepee with his hand—?

Surprise-! Hastily I put on a kimono!

Two girls were talking; one said, "He probably is not home."

"Hello there," (a woman's voice), "Anybody home?"

"Hello," I answered from within, "just a second." It was Virna, an artist, a girlfriend from Home Colony and Tacoma, come to pay her promised visit.

I then stepped to the door, threw it open. "Greetings, Virna I wondered who it was."

"Hello, Chenuis, meet my friend Betty. I told her about you and she wants to meet the wild man."…. "I was doing some printing," I said; and took up the brushes and made a few impressions while the girls watched.

After which the conversation turned to this and that. Virna said, "I brought along my camera and I would like to get some more pictures of you, in the raw."

Well! The Chief knew what she wanted were pictures of a naked man!

(Here we go)

"Do you know what I was up to when you arrived? I had thought up a new design to paint on myself and was doing it in dye!"

"Let's see it!" said both girls at once.

So off with the kimono, the body complete, my leg covered from hip down with this painted design in blue.

There was a brief silence.

"Will it wash off?"

"No, it's batik dye, hard to wash off; wears off gradually. What I intended was to have this concentric pattern all over me."

"But I am afraid, with one leg painted," said Virna, "it will spoil the pictures."

"Well," said I, "Looks like I better keep on and paint the rest of me." I take the brush and start to work on the other leg; presently I have difficulty in painting around in back, so I hand the brush to Virna, who proceeds with the job.

"Don't you think I'd better paint you all over? It'll look funny if only your legs are painted. And take the shirt off too, Betty won't run away."

Said I, "Of course the object of this body painting is the little game of Treason, in this case a dig at the Holy Establishment, the brainwashers. Certainly we will get erotic stimulus, what with Aphrodite and Eros—"

The girls giggle, but guess it will be all right,

So Chenuis enjoys the unusual pleasure of being body painted with an appreciating women audience—quite shameless. Virna continues to decorate me, covering my buttocks, my back, hips and belly, breast, shoulders, arms and face with paint. All of which is a distinct delight to me, to Betty and Virna.

It being about midday and the chief's savage decorations complete, we three start off on a tour of the vicinity, in search of suitable backgrounds for Virna's photographs.

Virna is absorbed by the scenes in her Graflex and gives directions to me.

I, the wild man, am having a fine time of it—spending a most memorable afternoon with two admirers. I wade in the creek, posture on the sward, pose against the sunlight, sneak through the reeds, hunt for wild fowl among the grass. I feel the exploring eyes of the girls playing over me deliciously, like invisible hands, but I remain unaware—happy!

Virna took many shots, on the beach, by the creek, on the grassy sward, in the woods, by the lagoon; there were abundant opportunities for photography and her films were soon gone.

Then we sat at the point at the mouth of the lagoon and talked, with Virna still busy seeing new poses in her view finder.[11] (figs. 3.28, 3.29, and 3.30)

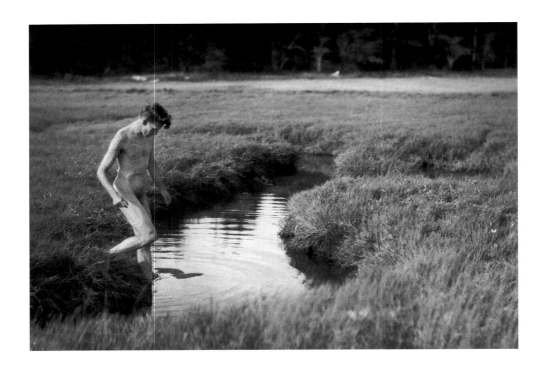

FIGURE 3.28.
VIRNA HAFFER, Untitled (Corwin Chase), 1929. Scanned from the original negative. Scan file restored and printed by Tod Gangler. Collection of the Washington State Historical Society, gift of the estate of Virna Haffer, 1974.35.1145.11a.

FIGURE 3.29.
VIRNA HAFFER, *Male Beauty*, 1929. Bromoil transfer print, 8 ⅞ x 7 ⅜ inches. Collection of the Washington State Historical Society, gift of the estate of Virna Haffer, 1974.35.12.33.

Haffer produced and exhibited several bromoil transfer prints from her 1929 negatives of Corwin Chase.

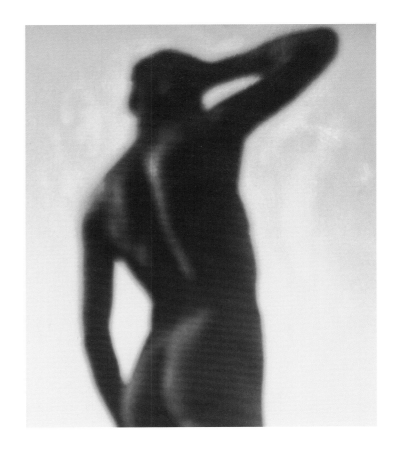

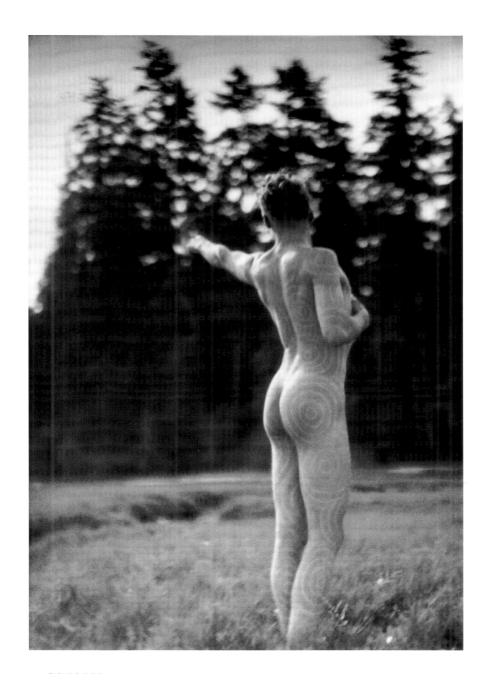

FIGURE 3.30.
VIRNA HAFFER, Untitled
(Corwin Chase), 1929.
Scanned from the original
negative. Scan file restored
and printed by Tod
Gangler. Collection of the
Washington State Historical
Society, gift of the estate of
Virna Haffer, 1974.35.1145.6a.

In late 1929 Virna and Jean moved to Encanto, a suburb of San Diego, where she concentrated on developing her photography skills. It is likely that Wayne Albee, who had moved to San Diego that same year, persuaded her to follow his lead.[12] During this time, she made numerous studies of cacti and floral subjects, both in photography and as block print subjects.

Haffer's career was now blossoming and beginning to receive national attention. In 1930 she was included in the SCC's final international exhibition, held at the Art Institute of Seattle (predecessor to the Seattle Art Museum), which took place even though the club had disbanded the previous year. That same year marked her first national exposure when *The American Annual of Photography* reproduced her photograph titled *Robert*, an innovative portrait of a bright-eyed young man. (fig. 3.31)

After living in California for approximately nine months, she returned to Tacoma and held her first local solo exhibition of twenty-seven block prints and forty-eight pictorial photographs in October 1930. Although most of the prints had been created over the past few years, the pictorial photographs included a range of works from the previous decade. Haffer had recently been producing bromoil prints, and several were included in this exhibition. Many pictorialists who admired the painterly effect that it imparted used the technique in monochrome as well as color. (fig. 3.32)

FIGURE 3.31.
VIRNA HAFFER,
Robert, circa 1928.
Gelatin silver print,
9 ¼ x 7 inches.
Collection of the
Washington State
Historical Society, gift
of the estate of Virna
Haffer, 1974.35.80.1.

Held in the lobby of Tacoma's Winthrop Hotel, the exhibition produced a great deal of publicity and received accolades in the local press. The Winthrop Hotel served as a venue for several prominent local artists, including Haffer, Thomas Handforth (1897–1948), and Allan Clark (1896–1950). These exhibitions were usually sponsored by or connected to the Aloha Club, the Tacoma women's organization whose members were and still are important patrons of regional art.

FIGURE 3.32.
VIRNA HAFFER,
Kwei Dun, circa 1929.
Bromoil transfer print,
9 ¼ x 7 ⁹⁄₁₆ inches.
Collection of the Tacoma
Public Library.

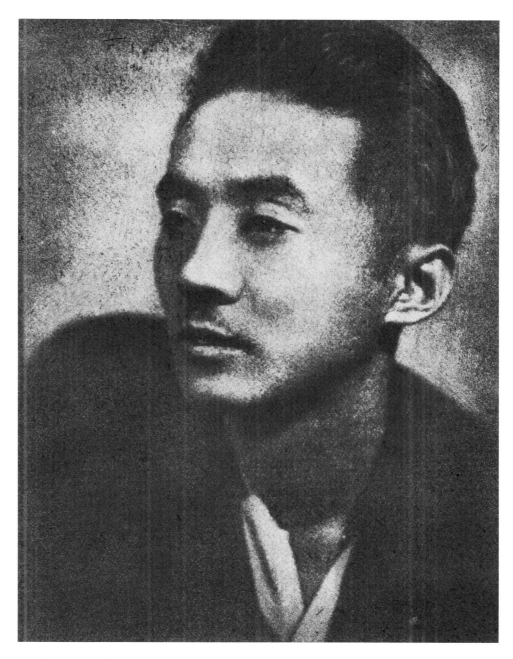

Haffer's clever idea to mix artistic portraiture of some of Tacoma's social elite with images of artists, nudes, and marginalized social and political figures produced a compelling exhibition. These contrasts perhaps mitigated the social backlash that some of the more unconventional and challenging works could have produced. For instance, one of the exhibited block prints, titled *Phallic Worshippers,* is an audacious depiction of an idealized young family (presumably representing Haffer, her husband, and son) standing naked before a large crucifix, surrounded by a glowing

FIGURE 3.33.
VIRNA HAFFER, *Phallic Worshippers*, circa 1929. Block print, 8 ¾ x 5 ¾ inches. The Randall Family Collection.

aura of light shaped like male genitalia. (fig. 3.33) Other block prints, such as *Family* and *Disillusionment*, depict the young family's bonding and eventual disaggregation. Paul and Virna were soon to be divorced, but she retained his last name for the remainder of her professional career. (figs. 3.34, 3.35, 3.36, and 3.37).

In 1931 her photographs were included in the *First International Salon, Camera Enthusiasts of San Diego*. Haffer's mentor, Wayne Albee, served as one of the judges, and in a letter written to the *Tacoma News Tribune and Ledger*, he commented on her entries. "The first, *Dancing Teacher* (fig. 3.38), is a study of Isabel Keith Morrison in a graceful pose against a striking background, and the second, *Mina Quevli*, is a striking example of composition and technique, catching in its rarity, the exotic quality of Miss Quevli."[13] Haffer's work *Dancing Teacher* was likely inspired by Albee's *In a Dancer's Studio*, which appeared in *Pictorial Photography in America* in 1922. (figs. 3.39, 3.40, 3.41, and 3.42) Around this time, Haffer began developing an international reputation when several of her prints began to be accepted in salons in Europe and Japan as well.

It is likely that Wayne Albee and Ella McBride, both of whom were known for their portraits of international dance figures, influenced Haffer to use dancers and actors prominently in her work. Her association with Erna Tilley and the Tacoma Drama League offered intriguing subjects for pictorial compositions. She made several studies of androgynous figures, such as actor Craig Boardman

FIGURE 3.34.
VIRNA HAFFER, *Disillusionment*, circa 1929. Block print, 5 ¾ x 8 ¾ inches. The Randall Family Collection.

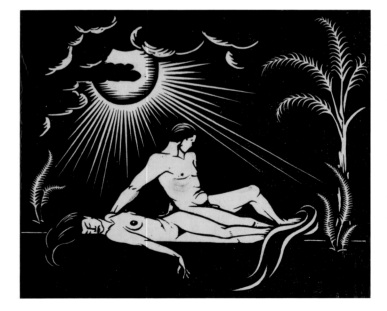

FIGURE 3.35.
VIRNA HAFFER, *Autumn*,
circa 1930. Block print,
13 ¼ x 8 ¾ inches. The
Randall Family Collection.

FIGURE 3.36.
VIRNA HAFFER, *Family*,
circa 1929. Block print,
7 ⅛ x 4 inches.
The Randall Family
Collection.

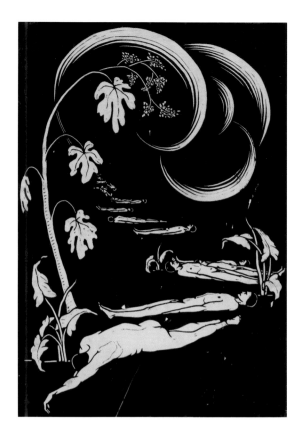

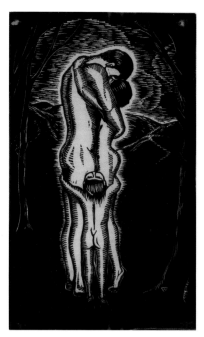

FIGURE 3.37.
VIRNA HAFFER,
Untitled (Corwin Chase),
1929. Scanned from the
original negative. Scan file
restored and printed by
Tod Gangler. Collection
of the Washington State
Historical Society, gift of
the estate of Virna Haffer,
1974.35.1141.6a.

Haffer used this
photograph of Corwin
Chase to compose the
male figure in her block
print titled *Autumn*.

FIGURE 3.38.
VIRNA HAFFER,
Dancing Teacher, circa
1930. Gelatin silver print,
12 ¼ x 10 ½ inches.
Collection of the
Washington State Historical
Society, gift of the estate of
Virna Haffer, 1974.35.12.30.

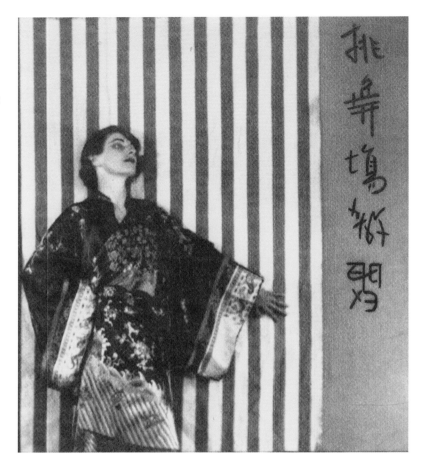

FIGURE 3.39.
WAYNE ALBEE
(American, 1882-1937),
In a Dancer's Studio as
illustrated in *Pictorial
Photography in America*,
1922. Courtesy of The
Seattle Public Library.

FIGURE 3.40.
VIRNA HAFFER,
Mina Quevli, circa 1930.
Gelatin silver print with
circular cropping line,
6 x 7 ¼ inches.
Collection of the
Washington State Historical
Society, gift of the estate of
Virna Haffer, 1974.35.11.17.

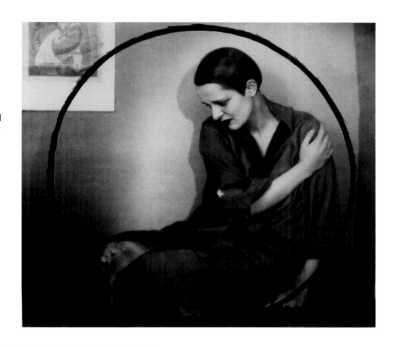

FIGURE 3.41.
VIRNA HAFFER,
Mina Quevli, circa 1930.
Paper negative print,
9 ¼ x 7 inches. Collection
of the Washington State
Historical Society, gift of
the estate of Virna Haffer,
1974.35.12.27.

To produce this unusual
image, Haffer created a
drawing based on her
study of Mina Quevli (fig.
3.40), which she then
photographed and made
into a print using a paper
negative and red ink. Her
block print *Japanese Noh
Dance – Sign of the Great
God,* can be seen in the
upper left corner of both
photographs.

FIGURE 3.42.
VIRNA HAFFER,
*Japanese Noh Dance – Sign
of the Great God*, circa 1929.
Block print on red paper,
10 x 10 inches. The Randall
Family Collection.

Haffer incorporated a sly
reference to the dollar sign
in the design of this print. On
other proofs of this print, the
title is simply indicated as $.

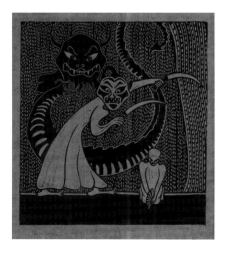

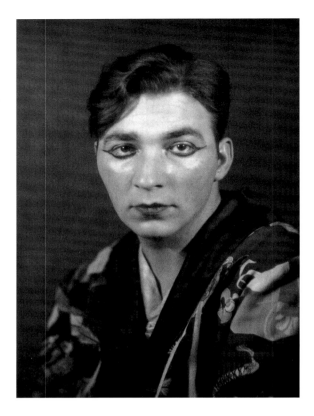

FIGURE 3.43.
VIRNA HAFFER, Untitled (Craig Boardman), circa 1930. Scanned from the original negative. Collection of the Washington State Historical Society, gift of the estate of Virna Haffer, 1974.35.10.714.1.

Craig Boardman was an actor friend of Haffer's who posed for several of her works. Boardman was deeply involved with regional theater groups in Seattle and Tacoma and served as a director for the Federal Theater Project in Tacoma during the Depression.

FIGURE 3.44.
VIRNA HAFFER, *Zella Newcomb*, circa 1928. Scanned from the original negative. Collection of the Washington State Historical Society, gift of the estate of Virna Haffer, 1974.35.10.812.1.

Besides being the editor for the cultural magazine *City of Destiny*, Zella Newcomb was a labor rights activist and was involved in several left-wing causes. In most of her extant photographs she is wearing masculine attire and short hairstyles.

and cross-dresser Zella Newcomb, a social activist and later editor for the short-lived regional magazine *City of Destiny* (figs. 3.43 and 3.44). Haffer's portrait of dancer Lee Foley enveloped in a flamenco costume is a bold composition and achieves the success of some of Albee's finest dance photographs, like his richly patterned study of Caird Leslie (1899–1970). (figs. 3.45 and 3.46)

During the summer of 1931, Haffer and her son made a cross-country trip, landing in Michigan where she photographed Detroit's Ambassador Bridge. Along the way they made stops in Chicago, Los Angeles, San Diego, Santa Fe, and other western regions, visiting friends and family. Haffer collected a great deal of material for producing photographs and block prints during the trip. In New Mexico she visited her old friend from Tacoma, sculptor Allan Clark, who had developed a significant international reputation. She photographed Clark as well as his adobe studio and even produced a study of his dog. Other artists that she photographed included Grace Spaulding John (1890–1972), Rolf Pielke (1886–1957), Onya La Tour (1896–1976), and Arnold

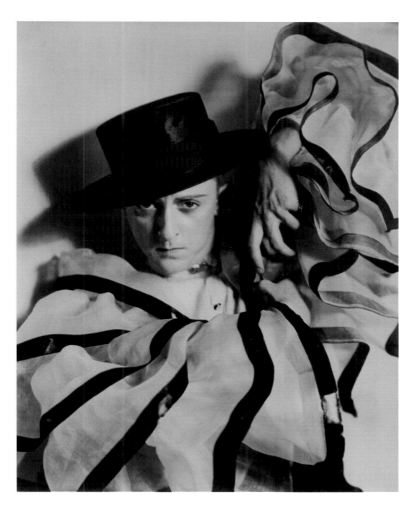

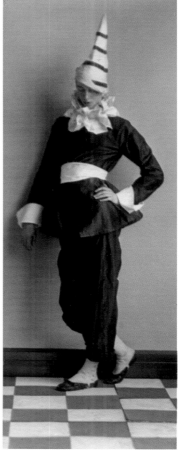

FIGURE 3.45.
VIRNA HAFFER,
Lee Foley, circa 1930.
Gelatin silver print, 9 ½ x
7 ½ inches. Collection
of the Washington State
Historical Society, gift of
the estate of Virna Haffer,
1974.35.11.22.

FIGURE 3.46.
WAYNE ALBEE (American,
1882-1937), McBride Studio,
Caird Leslie, circa 1922.
Gelatin silver print, 6 ½ x
2 ¼ inches. From the College
Archives of the Cornish
College of the Arts Library.

Lee Foley and Caird
Leslie were nationally
successful modern dancers
from Washington State
active in the early twentieth
century. They had
distinguished careers in
New York before returning
to Seattle to teach at the
Cornish School where they
exerted significant influence
on several generations of
regional dancers.

Franz Brasz (1888–1966) (see pages 34, 36, and 80), all of whom appeared in her pictorial compositions.

The results of these efforts were displayed in Haffer's second annual Tacoma exhibition, this time held at the studio of dancer Isabel Keith Morrison. The exhibition was comprised of seventy-one pictorial photographs, including her distorted portrait of Kay Harshberger, her chimera-like self-portrait (see cover illustration), and an informal study of Allan Clark. Other works in the exhibition were from her cross-country trip, such as *Chicago Ghetto* (see fig. 2.23, page 57) of which she also made a block print, several pottery studies, including *Zuni Bowl* and *Lime Kiln, an industrial subject.* A few months later, two of her photographs, the aforementioned *Self Portrait* and *The Bridge* (see fig. 3.16), were illustrated in Seattle's most prominent cultural publication, the *Town Crier*, in an essay on modern photography that also included Edward Weston and the Mexican modernist Agustin Jimenez (1901–1974).[14]

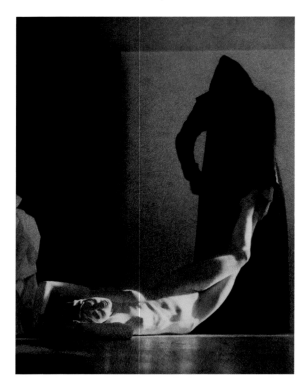

Haffer's work continued to gain regional and national visibility. She was included in the 1931–32 traveling exhibition *Prize Winning Prints*, organized by *American Photography*. Her work *Three Towers* (see page 80), a bromoil print, won fifth prize in the international competition and was illustrated in their September 1931 issue. Throughout the 1930s, her work would be regularly reproduced in national publications, including *American Photography*, *Camera Craft*, and *Photo Art Monthly*. Haffer's work *Cornelius Vanderbilt* (see fig. 2.25, page 58) was reproduced in *Camera Craft,* where it won an award in their September 1934 issue. It also won an Honorable Mention in *American Photography* in January 1935. Even though Haffer had experimented with distortion in the 1920s, this portrait shows the clear influence of the foresighted California pictorialist William Mortensen (1897–1965). His book *Projection Control* had been published in 1934 and contains instructions on the technique of distorting images.

The use of distortion and elongation were more commonly used by contemporary painters during that period. European artists like Amedeo Modigliani (1884–1920), Chaim Soutine (1894–1943), and especially the American painters Thomas Hart

Benton (1889–1975) and African American expatriate William H. Johnson (1901–1970), were highly influenced by the elongated figures of El Greco (1541–1614), one of the most visionary painters in the whole of art history. As several of the pictorialist photographers were also trained as painters, these techniques were spreading into the photographic field as well.

Like Haffer, William Mortensen worked in a broad range of styles that sometimes included unusual and dark subjects inhabited by grotesque and nightmarish figures. He produced a series of popular articles for *Camera Craft* throughout the 1930s and 1940s. His epic *Monsters and Madonnas: A Book of Methods* from 1936 is considered a classic in the field. (fig. 3.47)

Mortensen also used and manufactured textured photo screens to add crosshatching effects in his portraiture. Haffer made use of some of his manufactured screens, but she also made several of her own, sometimes altering the effect by printing the photograph with a paper negative to soften the lines. (figs. 3.48 and 3.49)

FIGURE 3.48.
VIRNA HAFFER, *Jim*, circa 1938. Paper negative print with texture screen, 13 ¼ x 10 ¼ inches. Collection of the Washington State Historical Society, gift of the estate of Virna Haffer, 1974.35.12.38.

FIGURE 3.49.
VIRNA HAFFER, Paper negative used to produce *Jim*, 13 ½ x 10 ¼ inches. Collection of the Washington State Historical Society, gift of the estate of Virna Haffer, 1974.35.12.37.

Virna Haffer was a unique individual. She made most of her own clothing and was a working musician who played saxophone, piano, and accordion. She was very stylish and made the most of her beauty by enhancing her best features. One big statement she made to assert her individuality was the makeover of her house and studio on South Stevens in Tacoma. At first the bungalow-style home was like most in the area, rather unassuming but well suited to her needs, but her encounters with two unusual houses helped shape her decision to turn her home into a work of art.

First, she became aware of the Spadena House in Beverly Hills on one of her trips

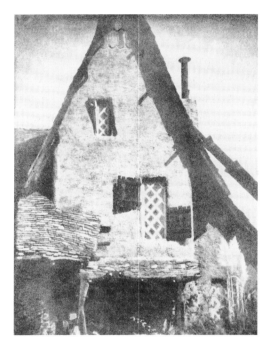

to California. Built in 1921, it resembled an enchanted house from a fairy tale, with meandering bricks, oddly shaped doors, and randomly placed windows. She was impressed and made several photographs of the house, one of which became an exhibition print titled *The House That Jack Built*. (fig. 3.50) Even though the photograph looks like one of Haffer's distortions, it was actually an accurate depiction of the residence.

Another unusual home that made an impression on her was Olympus Manor, a sixteen-room lodge constructed by the family of her friend, artist Orre Nobles (1894–1967). Built on the shores of Hood Canal near Union, Washington, the idyllic Manor welcomed its guests with a large Japanese *torii* gate that led to a retreat for Noble's menagerie of friends and fellow artists. (fig. 3.51) Once inside, the home was a startling mix of Asian, Native American, and European art and antiques and featured a large music and performance room that was used by regional and national artists who came to be in the company of the charismatic Mr. Nobles.[15]

FIGURE 3.50.
VIRNA HAFFER,
The House That Jack Built,
circa 1929. Bromoil print,
9 ½ x 6 ⅞ inches.
Collection of the
Washington State
Historical Society, gift of
the estate of Virna Haffer,
1974.35.11.6.65.3.

After a fire destroyed the Tacoma Hotel in 1935, Haffer and her son hauled the carrion bricks to their home, where she proceeded to create the unique edifice. Like individual talismans, the repurposed bricks that once housed the studio of her first employer, Harriette Ihrig, held many memories of the burgeoning cultural scene in Tacoma. They also united her with Norman Randall, a mining engineer whom she had met the previous year. After the fire destroyed his residence in the hotel, he moved into Haffer's home, where they remained together until his death. (fig. 3.52)

The redesigning of her home coincided with another of Haffer's artistic ventures, a collaboration with Bettie Sale to produce a book of Sale's poetry and Haffer's photographic illustrations. Begun in 1934, the book was scheduled to be published by The Writer's Press in New York in 1938. Although a prototype was made, the book was never published. Only Haffer's photographs and a few of the poems that were eventually published in *City of Destiny* survived.

The title of the book was to be *Abundant Wild Oats*, a reference to the phrase "sowing wild oats," which traditionally was used to describe a young man's indiscriminant sexual endeavors. It was rarely, if ever, used to describe female sexuality. But in this case, Sale was not only appropriating the term for her own personal expression but was celebrating her independence as a woman whose nonconformist personal life went against the grain of the social mores of the time. The main theme of the book was described in a promotional pamphlet as "A daring, remarkable poem sequence revealing the erotic exultation of a woman of many loves, by a poet who has breathed the redolence of strange romances into words of intimate rapture and sensate feeling." (see page 137) Perhaps the erotic content, especially expressed by two women, was the cause of the book never being published, or perhaps it was just another casualty of the economic depression.

Washington State certainly had its share of innovative artists in the early half of the twentieth century, but among the region's photographic artists there is nothing comparable to the striking series that Haffer produced for this publication. Her photographs are an outstanding blend of pictorialism intoned with surrealism and abstraction.

The illustrations that Haffer produced for the book were quite advanced for the time. During the creative process, she began experimenting with the manipulation of her negatives to produce images that were abstract yet had some type of figurative reference. These works were reproduced in an article written by Haffer titled "A Novel Form of Trick Photography," which was published in the June 1939 issue of *Photo-Art Monthly*. Using her husband and a few male friends as models, she isolated different parts of their bodies and then combined positive and negative printing, overlapping the negatives to create strange hybrid forms. (see fig. 1.12, page 20 and pages 11 and 76) She explained, "Having made a number of negatives for an illustration in a group of them I was doing at that time, was at a standstill, more or less lost. What I had was not what I wanted. Several of these negatives were pretty much alike, and having turned one over, thereby reversing it, I noticed they formed peculiar designs and figures."

ALASKA INTERLUDE

In the summer of 1938, Haffer visited Alaska and produced a series of Alaskan-themed works while traveling in the Windham Bay region. In November of that year, she held a solo exhibition in the social room of the local Methodist Church in Juneau. The honor of having her first solo exhibition in Alaska, albeit in a minor venue, was diminished when she was referred to as "Mrs. Berna Haffner-Randall" in the local newspaper.[16] (fig. 3.53)

The following summer, Haffer returned to Alaska—this time with Bettie Sale—with the idea of collaborating on a publication of pictorialist photographs titled *Alaska and the Yukon Territory*. During this trip, she was purported to have been commissioned by *Life Magazine* to photograph the spectacular ice-breakup of the Nenana River, north of Denali National Park. However, the two women arrived too late in the season and missed the spectacle. The thwarted opportunity was noted in the press with the statement, "Ice waits for no women."[17] Like their previous collaboration, this book found no publisher, but Haffer created a scrapbook version of the proposed publication with dozens of superb depictions of Alaskan landscapes, cityscapes, industrial activities, and Native Alaskan studies. (figs. 3.54, 3.55, and 3.56)

FIGURE 3.53. Photographer unknown, One of Virna Haffer's exhibitions in Alaska, circa 1938. Scanned from the original negative. Collection of the Washington State Historical Society, gift of the estate of Virna Haffer, 1974.35.11.4.51.1.

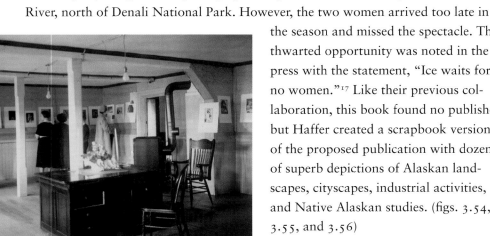

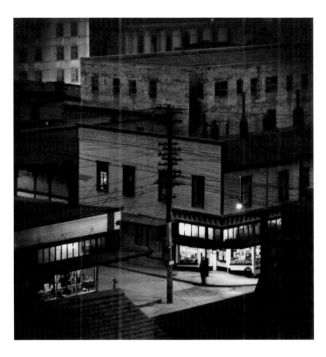

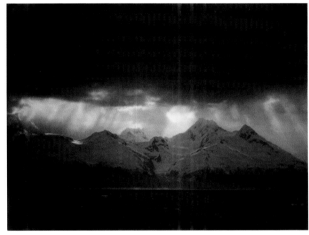

FIGURE 3.54.
VIRNA HAFFER, *Juneau*,
circa 1938. Gelatin silver print,
8 ¾ x 8 inches. The Randall
Family Collection.

FIGURE 3.55.
VIRNA HAFFER, *Icy Straits*,
circa 1938. Gelatin silver print,
8 x 9 ⅞ inches. The Randall
Family Collection.

FIGURE 3.56.
VIRNA HAFFER, *Totem-Ketchikan*, circa 1938.
Gelatin silver print, 8 ¾ x 8
inches. The Randall Family
Collection.

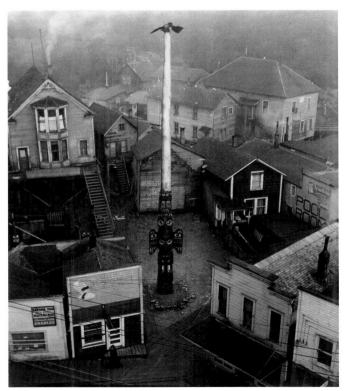

Haffer publicized her Alaska trip in the local newspapers with the dual purpose of having exhibitions of her artistic work and, at the same time, soliciting portrait commissions. She placed large advertisements in the Fairbanks and Anchorage newspapers offering a "once-in-a-lifetime opportunity" to have portraits made at her makeshift studios in the hotels in which they were staying. She connected with women's clubs and organizations to sponsor her exhibitions and to entice some portrait work for added income.

ARTISTIC MATURITY

When Haffer returned to Tacoma she continued to exhibit regionally, nationally and internationally. In May 1940, as a member of the Tacoma Camera Club, Haffer helped organize the *First Salon of Photography* and served as juror. The salon attracted numerous longstanding pictorialists, including Dr. Max Thorek (1880–1960) of Chicago, Eleanor Parke Custis (1897–1953) of Washington, D.C., and Frank R. Fraprie (1874–1951) of Boston, as well as others who had exhibited in Northwest salons for decades.

FIGURE 3.57.
VIRNA HAFFER,
Portrait of Jean Randall Age 18, 1941. Kodachrome with added pigmentation, 9 ½ x 7 ⅛ inches. Collection of the Washington State Historical Society, gift of the estate of Virna Haffer, 1974.35.12.41.

She soon started advertising the use of color photography in her portrait studio. The Kodachrome film produced vivid and rich naturalistic effects, and she was anxious to add it to her commercial repertoire. (fig. 3.57)

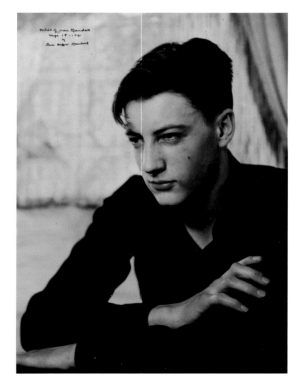

In 1942 Haffer's world changed when her long-time friend and collaborator Yukio Morinaga (fig. 3.58), along with her SCC mentors, Dr. Koike and Frank Kunishige, were sent to internment camps, first in Puyallup, Washington, and then to Minidoka in Idaho. Her Issei friends from whom she learned so much and who had such a profound influence on her professional career now suffered the indignities of being incarcerated for no reason other than their race. (fig. 3.59) When Morinaga was released in 1945, he moved to Tacoma into a small house that Haffer had purchased for him, in which he could work and pay minimal rent.

In 1946 Haffer became a grandmother with the birth of her first grandchild, Norman, followed by a granddaughter, Jacky, in 1949. In June 1950

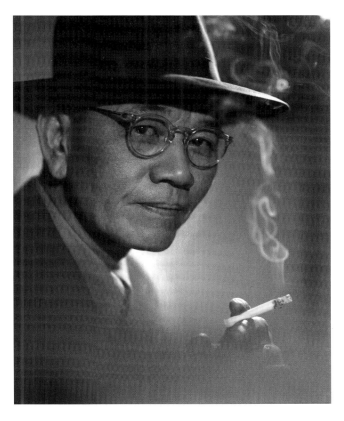

FIGURE 3.58.
VIRNA HAFFER,
Yukio Morinaga, 1946.
Scanned from the original
negative. Collection of the
Washington State Historical
Society, gift of the estate of
Virna Haffer, 1974.35.10.0.1.

FIGURE 3.59.
YUKIO MORINAGA
(American, born Japan,
1888-1968), Front and
interior of a Christmas card
depicting the Minidoka
internment camp near
Twin Falls, Idaho, 1943. The
Randall Family Collection.

Yukio Morinaga sent this
card to Virna Haffer in
December of 1943.

her beloved husband passed away at the age of fifty-nine. Although their relationship had sometimes been turbulent, Norman Randall had been a perfect match for his unconventional wife, and he also won the heart of her son Jean. By then, the young man had selected the more Americanized version of his name, Gene, and added Norman as his middle name after he was adopted by his step father. He continues to this day as Gene Randall.

A few months after her husband's death, Haffer took an extended trip to Europe, where she produced hundreds of negatives. The results of her European trip were displayed in Tacoma's Winthrop Hotel, which had long supported her work. Over the next few years, she became more active with local camera clubs, like the Tacoma Photographic Society, which formed in 1956 and the Seattle Photographic Society which she had been active with since the 1930s.

One of her great achievements came in October 1960 when the Massachusetts Institute of Technology in Cambridge mounted a retrospective of seventy of her best salon prints created over the past fifty years.

By 1962 Haffer began gaining recognition for her photograms, the process of creating photographic images without the use of a camera. Some of her best works in this medium were displayed at the Century 21 Exposition, also known as the Seattle World's Fair, a fine venue for mass exposure. The fair ran from April 21 through October 21, 1962, and Haffer's display ran for one week during this period, beginning on June 17. (fig. 3.60) Although there were several prominent exhibitions of contemporary American, European, and regional painting and sculpture at the fair, Haffer's photograms held their own as striking, if somewhat confusing, innovations.

FIGURE 3.60.
Photographer unknown, Interior view of Virna Haffer's photogram exhibition at the Seattle World's Fair, June 17, 1962. Scanned from the original negative. Collection of the Washington State Historical Society, gift of the estate of Virna Haffer, 1974.35.10.2821.2.1.

Some of the images would have appeared to be traditional photographic depictions of landscapes, florals, and other hybrid designs. But these deceptive images were actually created from an assemblage of torn paper and found material strategically placed on sheets of glass and exposed onto sensitized paper. Mixing positive and negative prints and often stacking the supports to produce a greater depth of illusionary space, Haffer had found her métier, the perfect crowning achievement of a lifetime of dedication to the medium.

In her sixties, when many others are easing into retirement, Haffer was still going strong. While experimenting with photograms, she simultaneously maintained her commercial portrait studio and continued to make pictorial photographs, including a series on doors and bridges as well as unique landscapes that were frequently published in the local press.

The year 1964 brought a great deal of activity and success to Haffer. Both her series of doors and her series of rock formations in Death Valley were featured in Tacoma's *News Tribune and Sunday Ledger*. In addition, seventy-five prints from her series of doors were exhibited at the California Museum of Science and Industry in Los Angeles. That same year, Haffer's career was nationally honored in Chicago, when she was awarded a master's degree from the Professional Photographers of America.

FIGURE 3.61.
VIRNA HAFFER,
California Horizon,
circa 1962. Photogram,
7 ⅜ x 19 ⅞ inches.
Collection of the
Washington State
Historical Society, gift of
the estate of Virna Haffer,
1974.35.71.1.

According to the prestigious organization, "To earn the degree a photographer must contribute years of consistently outstanding service to the profession, and achieve general excellence of photographic artistry and craftsmanship."[18]

Haffer continued to create photograms, using the medium to express her concerns for the environment and nuclear obliteration. Some of her most powerful works include *California Horizon* (fig. 3.61) and the remarkable *Tomorrow World* (see fig. 1.32, page 30), in which commanding and terrifying shadows foretell a bleak futuristic nightmare without any hope of redemption. She created these images with diverse objects, such as desiccated rodents, animal skeletons, and bones, along with paper, grasses, and detritus from her garden. Some of the abstract works, with no relatable or recognizable imagery, confront the viewer with a confounding visual exchange. While some are mysteriously beautiful, others are threatening and unsettling. She experimented with the random crystallization of drying chemicals and mixed antipathetic substances, such as cellophane and water, to produce bizarre shapes that allude to unrecognizable or primitive life forms. (see fig. 1.26, page 27) Although some of her more fascinating images came about through improvisation and chance, they were all developed through her masterful command of technique. In describing these works, Haffer explained that

> *the patterns achieved may not resemble anything—or they may. But this is not the point, they have the peculiar beauty of those patterns which are a source of fascination from childhood onwards. They are permanent formations but resemble those shapes seen in oil on a wet road or the faces in a fire—things that one glimpses before they are gone, which one recalls but never records.*[19]

In 1968 her beloved friend Yukio Morinaga passed away, having endured years of poor health and the ravages of heavy smoking. Morinaga was destitute upon his release from Minidoka over twenty years earlier and had it not been for Haffer's

intervention, his life would have been even bleaker. Frustrated and indignant from his five-year confinement, Morinaga refused to pay any more income taxes in a small act of defiance against the government of his adopted country. When his health declined, he starved himself to hasten his demise and died on June 12, 1968, at the age of eighty. A year later, Haffer wrote a short personal story based on her forty-year friendship with Morinaga but wrote it in the third person from the point of view of a man. Referring to Morinaga as "Mr. Mori," she titled her story "A Long Chain of Events."

> *If he hadn't been a camera bug, then he'd not have gone to that meeting where he'd met Mr. Mori and later became quite good friends. And if the war hadn't come along and sent Mr. Mori to the concentration camp (the government people liked to call it relocation camp) but in his own mind it was, it surely was a concentration camp. And when Mr. Mori came back and there was absolutely no place for him to go, he rented him that house. Well, he'd sort of bought the house when there didn't seem much else where Mr. Mori could go. Mr. Mori had lost his business at the start of the war and practically every item connected with it, when he had to leave. Nothing to come back to. So, after the war Mr. Mori had been his tenant—he guessed you could call him a tenant—he had been for years—ever since the war— that is until he died, when counting it up was quite a long time. And when Mr. Mori got down to where he couldn't get around anymore to buy his own groceries he had taken the job of buying them for him. It was little enough for one person to do for another. So when Mr. Mori died there was his groceries, and all that stuff to sort out and get rid of or give away.*[20]

This story was based in reality. Haffer did care for Morinaga and returned his few personal belongings to a brother still living in Japan at the time of his death. She retained a selection of his award-winning prints, enough to ensure the survival of his artistic reputation for the future. At one point in the 1920s, he had been the second most highly exhibited photographer in the world, but he would certainly have been forgotten and lost to history had it not been for her.

Haffer ensured her own reputation by writing a book titled *Making Photograms: The Creative Process of Painting with Light*, which was first published by Hastings House in 1969 and is still a sought-after reference manual. Haffer began writing a follow-up second edition, which was unpublished at her death but remains in manuscript form in the collection of the Tacoma Public Library.

1 Tacoma's Washington Camera Club was incorporated on May 28, 1900. *International Annual of Anthony's Photographic Bulletin and American Process Yearbook* (New York: E. & H. T. Anthony & Co., 1902), 14:362.

2 For further information on Albee, see David F. Martin and Nicolette Bromberg, *Shadows of a Fleeting World* (Seattle: University of Washington Press, 2011).

3 *Wilson's Photographic Annual* (New York: Edward L. Wilson, 1901), 38:272.

4 Herbert Hunt, *Tacoma, Its History and Its Builders: A Half Century of Activity* (Chicago: The S. J. Clarke Publishing Company, 1916), 2:562–64.

5 Virna Haffer scrapbook, n.d.

6 Gene Randall, telephone conversation with author, January 26, 2011.

7 Elizabeth Sale, "A Tribute to Virna Haffer" (unpublished manuscript, 1971), 3–4. Haffer archive, Randall Family Collection.

8 "Girl Scores Big as Artistic Photographer," *Tacoma* (WA) *Daily Ledger*, November 18, 1906.

9 Information about Ihrig's time in Spokane provided by Rose Krause, Johnston-Fix Curator of Special Collections, Northwest Museum of Arts & Culture/Eastern Washington State Historical Society.

10 *Seattle* (WA) *Times*, October 31, 1920, Sunday edition.

11 W. Corwin Chase, *Tepee Fires* (Burley, WA: Coffee Break Press, 1981), 89–90.

12 Although there is proof of Haffer having some type of personal or professional relationship with Albee, I have surmised that they likely had a close friendship, with Albee acting as mentor to Haffer. Haffer's estate contained several of his exhibition prints, some created in Washington and others created after his move to California. The only other body of work by another photographer in her estate was that of Yukio Morinaga, her close friend.

13 Wayne Albee, letter to the editor, *Tacoma* (WA) *News Tribune and Ledger*, June 8, 1931.

14 "Progressive Photography," *Town Crier* (Seattle, WA), December 5, 1931.

15 For information concerning Orre Nobles, see Erna Spannagel Tilley, "A Gateway to Friendship," (self-published, Seattle-Tacoma, 1970).

16 "Photographic Exhibit Here Weds., Thurs.," *Daily Alaska Empire* (Juneau), November 8, 1938.

17 "Misses Haffer and Sale Touring North," *Dawson News* (Yukon, AK), June 20, 1939.

18 "Tacoma Photographer Wins Master's Degree," *Tacoma* (WA) *News Tribune and Sunday Ledger*, August 12, 1964.

19 Virna Haffer, *Making Photograms: The Creative Process of Painting with Light* (New York: Hastings House Publishers & Amphoto, 1969), 70.

20 Virna Haffer, *A Long Chain of Events* (unpublished manuscript, October 20, 1969), Haffer archive, Randall Family Collection.

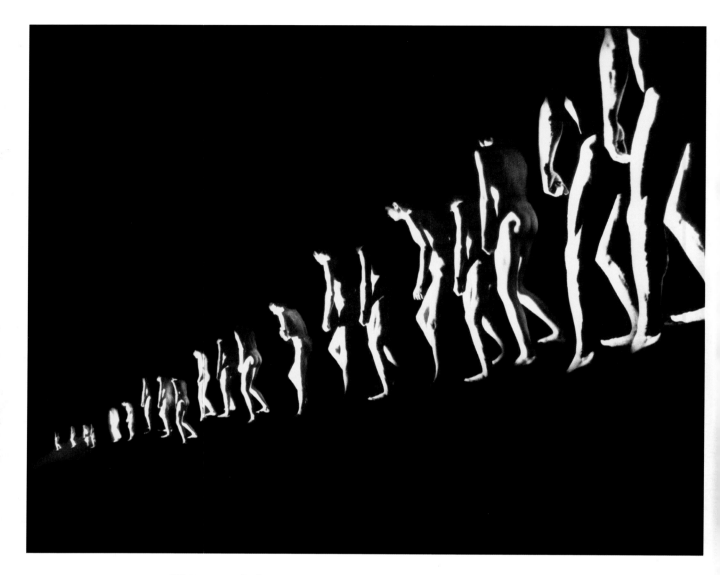

VIRNA HAFFER, *Dedication,*
circa 1934. Gelatin silver print,
11 x 14 inches. Collection of the
Washington State Historical
Society, gift of the estate of
Virna Haffer, 1974.35.12.8.

This image was used as the
front and back inside covers for
Abundant Wild Oats.

GALLERY THREE

ABUNDANT WILD OATS

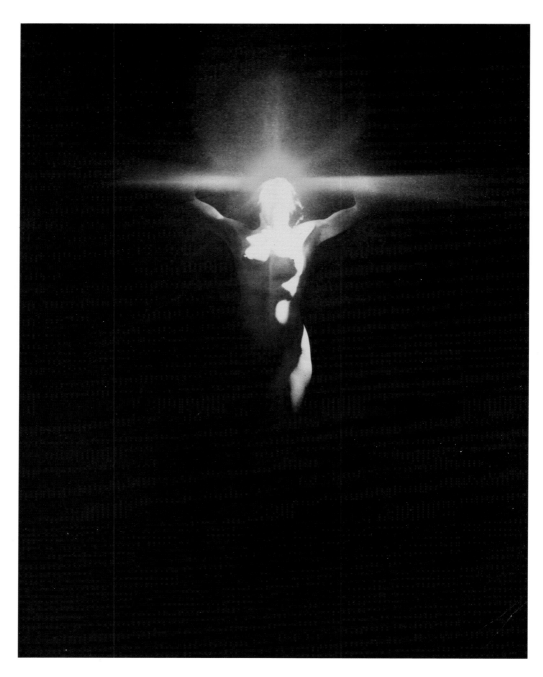

VIRNA HAFFER, *Lost Wife*,
circa 1934. Gelatin silver
print, 9 ⅝ x 7 ¼ inches. The
Randall Family Collection.

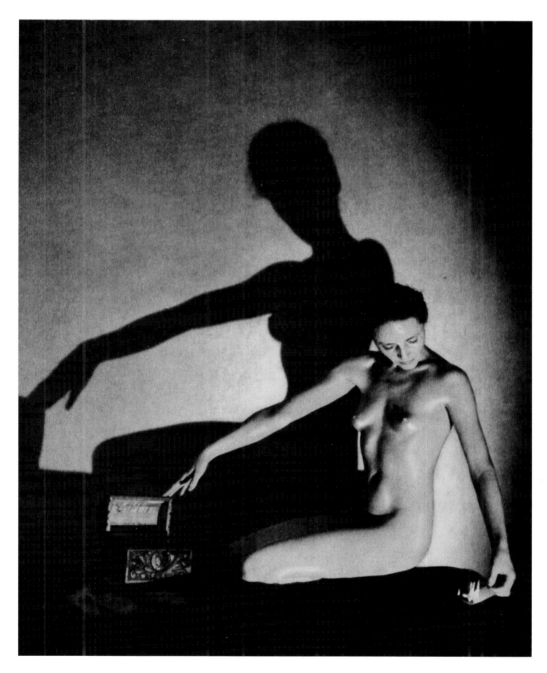

VIRNA HAFFER, *Almost
I Understood*, circa 1934.
Gelatin silver print,
9 ³⁄₈ x 7 ¼ inches. The
Randall Family Collection.

VIRNA HAFFER, *Even The Ghosts of Moths*, circa 1934. Gelatin silver print, 9 ³⁄₈ x 7 ¹⁄₄ inches. The Randall Family Collection.

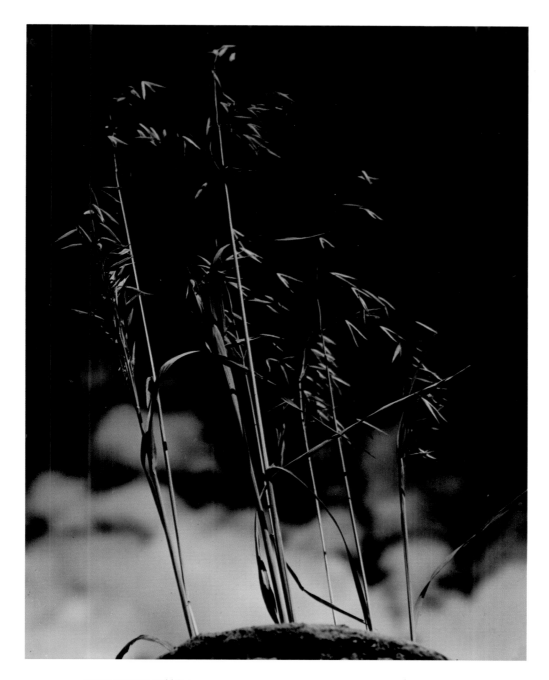

VIRNA HAFFER, *Wild Oats,*
circa 1934. Gelatin silver
print, 9 ⅜ x 7 ¼ inches. The
Randall Family Collection.

Top:
VIRNA HAFFER, *None Remember*, circa 1934. Gelatin silver print, 9 ³⁄₈ x 7 ¹⁄₄ inches. The Randall Family Collection.

Bottom:
VIRNA HAFFER, *With A Weird Spark*, circa 1934. Gelatin silver print, 9 ³⁄₈ x 7 ¹⁄₄ inches. The Randall Family Collection.

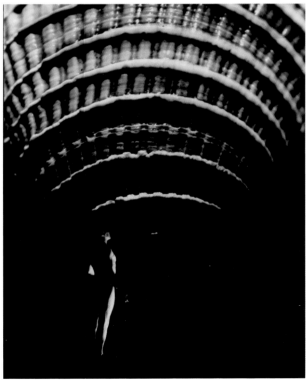

VIRNA HAFFER, *Down Isles of Tragic Twilight*, circa 1934. Gelatin silver print, 9 ⅜ x 7 ¼ inches. The Randall Family Collection.

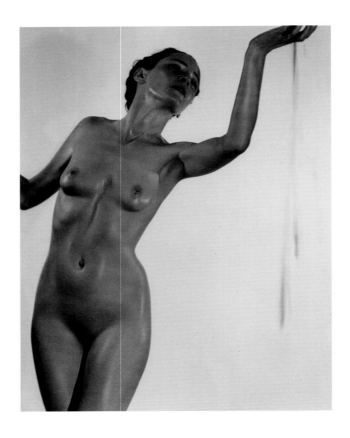

Top:
VIRNA HAFFER, *Hold Life Very Lightly,* circa 1934. Gelatin silver print, 9 3/8 x 7 1/4 inches. The Randall Family Collection.

Bottom:
VIRNA HAFFER, *Those I Have Tendered My Other Lovers,* circa 1934. Gelatin silver print, 9 3/8 x 7 1/4 inches. The Randall Family Collection.

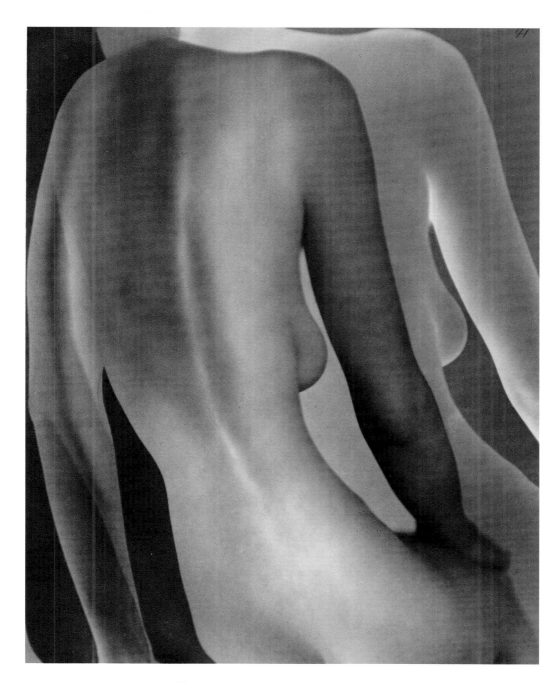

VIRNA HAFFER, *Rest Here
Your Sword*, circa 1934.
Gelatin silver print,
9 ⅝ x 7 ¼ inches. The
Randall Family Collection.

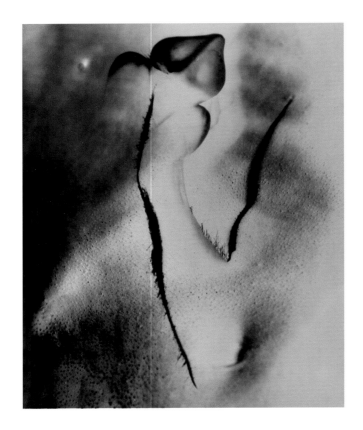

Left:
VIRNA HAFFER, *Dark Man*, circa 1934. Gelatin silver print, 9 ³⁄₈ x 7 ¹⁄₄ inches. The Randall Family Collection.

Right:
VIRNA HAFFER, *Into Cool Music*, circa 1934. Gelatin silver print, 9 ³⁄₈ x 7 ¹⁄₄ inches. The Randall Family Collection.

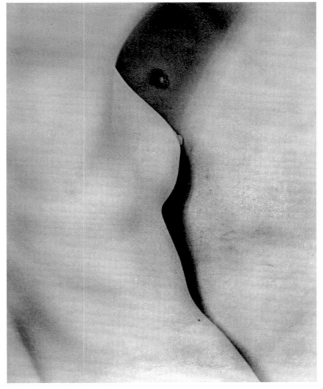

ABUNDANT WILD OATS

BY BETTIE SALE

■■■■ A daring, remarkable poem-sequence revealing the erotic exultation of a woman of many loves, by a poet who has breathed the redolence of strange romances into words of infinite rapture and sensate feeling. What Laurence Hope portrayed against a background of Oriental sound and color, Bettie Sale has voiced in her lyrics of Bohemian existence. They are being collected in one volume for the first time: a modern de luxe edition, featuring startling photographic illustrations by Virna Haffer whose many honors include the *First Advanced Medal of Camera Craft*; pictures published in the *American Annual of Photography* and many other magazines; prints exhibited in important salons in the United States, Canada and Europe. Noted for her pictorial photography, Virna Haffer has never displayed finer technique nor come closer to the mood of her subject than in her bold illustrations for *ABUNDANT WILD OATS.*

■■■■ *"These are poems! This woman is a poet!* It was two this morning when I finished reading these poems . . . almost flawless and filled with amazing beauty that does not fade out. I read every line, at times aloud, and was deeply moved by their loveliness and truth. There is no denying these are Love poems; Love as Omar pictured it, Love as Solomon pictured it. I have never been so heartened, so refreshed, so stirred by exquisite poetry by any modern writer." CHARLES HARDY MEIGS, *eminent author and critic.*

■■■■ "Bettie Sale has braved the criticism of the conventionally minded, expressing the Bohemian side of life. Imagery and fire are in her line. I was proud to claim her as one of my dis-

PHOTOGRAPHIC ILLUSTRATIONS BY
VIRNA HAFFER

Designed by Lewis F. White and product of the L. F. White Press this case-bound gold-stamped volume, page format 7½ by 10 inches, will be a modern rendition by a typographer whose creations have been adjudged among "The Fifty Books of the Year". Cloth bound over boards the cover will be blanked with a photogravure reproduction of one of Virna Haffer's rare photographic interpretations, the others created especially for this volume, appearing on the toned antique text pages used throughout the book, the sheets of which will be processed by both gravure and letterpress.

coveries when I was publishing *Muse and Mirror, The Northwest Poetry Magazine,* though truly she discovered herself long before the beginning of our acquaintance. Her earliest poems were mature and finished. Editors have fought for her, housewives have fought about her, versifiers have envied her, poets have adored her! Read *ABUNDANT WILD OATS* and thrill again to pure poetry." HELEN MARING, *well known Western poet.*

■■■■ "An arresting book. The author has something to say and is not afraid to say it in spite of the frowns and belaborings she will earn. Bettie Sale sings of life and when a sharp emotion turns up is not likely to sneak around it on dots and dashes. She faces it, caresses it, and presently translates it into words capable of recreating it in the reader. As frank as an Elizabethan, as curious as this year's girl graduate, she sets forth in graceful verse exactly those ideas which hit the normal human being hard and often." (Foreword to *ABUNDANT WILD OATS*) JOHN RUSSELL MCCARTHY, *one of California's finer lyricists.*

■■■■ "I am glad to know that Bettie Sale, who has won so many prizes for poetry printed in the magazine section of the *Spokane Daily Chronicle,* who has been published by the *New York Herald Tribune, Frontier-Midland, Rob Wagner's Script,* and reprinted in the *Literary Digest,* is to become better known through the publication of her distinctive poem-sequence, *ABUNDANT WILD OATS."* HENRY A. PIERCE, *News Editor, The Spokane Daily Chronicle.*

LIMITED DE LUXE FIRST EDITION PUBLISHED EARLY IN 1938 BY THE WRITERS' PRESS · 112 EAST 17TH STREET · NEW YORK

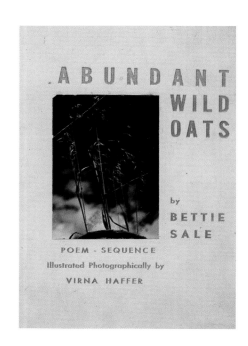

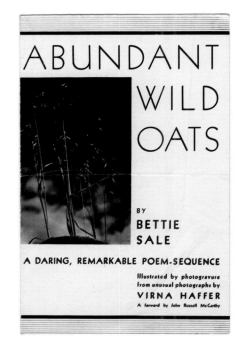

VIRNA HAFFER, Study for *Dedication*, circa 1934. Scanned from the original negative. Collection of the Washington State Historical Society, gift of the estate of Virna Haffer, 1974.35.10.1654R.8.

Around 1934 Haffer began making studies for the illustrations for *Abundant Wild Oats*. She posed her husband Norman Randall in her studio with a neutral backdrop and backlighting. To produce the results she was seeking, she used her Graflex revolving magazine holder to take multiple exposures on several films. The resulting images were sandwiched together and printed, creating unique, surrealistic effects.

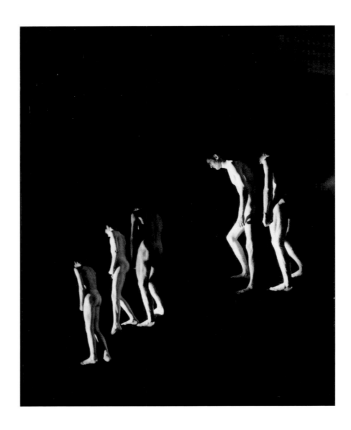

VIRNA HAFFER, Study of lips for *Those I Have Tendered My Other Lovers*, circa 1934. Scanned from the original negative. Collection of the Washington State Historical Society, gift of the estate of Virna Haffer, 1974.35.10.1654w.2.

VIRNA HAFFER, Study for *Dark Man*, circa 1934. Scanned from the original negative. Collection of the Washington State Historical Society, gift of the estate of Virna Haffer, 1974.35.10.1654X.3

Haffer photographed the shaved torso of her friend Craig Boardman, creating a stubbled surface as a base for the montage.

VIRNA HAFFER, Study for *Dark Man*, circa 1934. Scanned from the original negative. Collection of the Washington State Historical Society, gift of the estate of Virna Haffer, 1974.35.10.1654X.4

Haffer photographed her husband Norman's arm and bicep using backlighting in the studio and distorted it to create the right side of the composition.

VIRNA HAFFER, Study for *Dark Man*, circa 1934. Scanned from the original negative. Collection of the Washington State Historical Society, gift of the estate of Virna Haffer, 1974.35.10.1654X.5.

Haffer carved a piece of Ivory Soap in the shape of abstracted male genitalia with a tail-like appendage. After making several positive and negative printings of the carving, she introduced it into the center and left side of the montage. In the lower left quadrant, she burned and dodged the tail section to produce a protruding dimensional illusion.

VIRNA HAFFER, *They Shall Spread a Feast* (also titled *We'll Tease Them, Toast Them!*), circa 1934. Gelatin silver print, 5 ½ x 7 ½ inches. The Randall Family Collection.

This was an alternate image for *Abundant Wild Oats* not used in the final editing.

VIRNA HAFFER, Alternate image for *Almost I Understood*, circa 1934. Gelatin silver print, 14 x 11 inches. Collection of the Washington State Historical Society, gift of the estate of Virna Haffer, 1974.35.12.7.

VIRNA HAFFER, Study
for *None Remember*,
circa 1934. Scanned
from the original
negative. Collection
of the Washington
State Historical
Society, gift of the
estate of Virna Haffer,
1974.35.10.1654Q.2.

TACOMA ART MUSEUM
BOARD OF TRUSTEES, 2010–2011

TACOMA ART MUSEUM STAFF

Stephanie A. Stebich, Director

Derrek Bull, Security Officer

Margaret Bullock, Curator of Collections and Special Exhibitions

Melinda Campbell, Assistant Store Manager

Irene Conley, Security Officer

Kelly Crithfield, Assistant to the Director and Administrative Coordinator

Frank Culhane, Manager of Facilities and Security

Matthew Daugherty, IT Systems Administrator

Joy Doan, Visitor Services Representative

Zoe Donnell, Curatorial Coordinator

Thomas Duke, Manager of Membership and Annual Giving

Tobin Eckholt, Manager of Development Services

Lauren Faulkner, Collections Data Entry Assistant

Cameron Fellows, Deputy Director and Director of Administration and Finance

Katie Ferguson, Visitor Services Representative

Meredith Hankins, Graphic and Web Design Coordinator

Kara Hefley, Director of Development

Angela Hudson, Museum Educator for Youth and Family Programs

Rock Hushka, Director of Curatorial Administration and Curator of Contemporary and Northwest Art

Ellen Ito, Exhibition and Collection Assistant

Megan Jones, Visitor Services Lead

Laurel Jordan, Visitor Services Representative

Chloe Kadel, Visitor Services Representative

Laurel Kolkind, Visitor Services Representative

Bounsouane Lameny, Security Officer

Bryce Macdonald, Security Officer

Lisa McKeown, Communications Coordinator

Jeff Melton, Visitor Services Representative

Meghan Mitchell, Visitor Services Representative

Jennifer Peters, Visitor Services Lead

Josh Proehl, Community Programs Coordinator

Linda Rabadi Fair, Manager of Foundation and Corporate Relations

Vitoria Ramos, Visitor Services Representative

Peter Reilly, Collections Data Entry Assistant

Michelle Reynolds, Visitor Services Representative

Megan Ristine, Education Assistant

Kristen Shapton, Visitor Services Representative

Cyrus Smith, Museum Preparator

Jonathan Smith, Finance Manager

Samantha Sonju, Campaign Manager

Jon Spencer, Chef and Café Manager

Pei Pei Sung, Graphic Designer

Melissa Traver, Director of Marketing

Courtney Vowels, Director of Education

Jana Wennstrom, Manager of Public and Volunteer Programs

Jessica Wilks, Registrar

Kristie Worthey, Associate Director of Museum Services

Jessica Ziegenfuss, Security Officer and Development Assistant